A Postcard From
WATFORD
JOHN COOPER

AMBERLEY PUBLISHING

Also by John Cooper

A Harpenden Childhood Remembered: Growing up in the 1940s & '50s
Making Ends Meet: A Working Life Remembered
A Postcard From Harpenden: A Nostalgic Glimpse of the Village Then and Now
Watford Through Time

To My Dear Grandchildren

First published 2012

Amberley Publishing
The Hill, Stroud
Gloucestershire, GL5 4EP
www.amberley-books.com

Copyright © John Cooper, 2012

The right of John Cooper
to be identified as the Author of this work
has been asserted in accordance with the
Copyrights, Designs and Patents Act 1988.

ISBN 978 1 4456 0729 0

British Library Cataloguing in Publication Data.
A catalogue record for this book is available from
the British Library.

Typeset in 9.5pt on 11pt Celeste.
Typesetting by Amberley Publishing.
Printed in the UK.

Introduction

The early part of the twentieth century, the period from about 1900 to those dark days that were the First World War, is universally accepted as the golden age of the picture postcard. It was a fast and inexpensive form of communication, where a message sent in the morning could very often be delivered to the recipient by the afternoon post the same day. Although the telephone, developed by Alexander Graham Bell in the mid-1870s, was available, it was not in general use then to the extent that it is now and certainly not among the less affluent members of society.

Although many postcards unfortunately ended up in a waste-paper basket and were subsequently destroyed, many more were lovingly preserved in albums, thus spawning a popular hobby that still thrives to this day.

With subject matter too numerous to mention here, it is the topographical views of our villages and towns, frozen in time, that provides us with so much pictorial information of our past, which sadly through the progress of modernisation over the years has all too often disappeared for ever.

In Watford we are indeed fortunate to have had dedicated photographers such as Frederick Downer, William Coles, Harry Cull, Gregg Couper and others, who have painstakingly captured images of major fires, the floods that regularly turned roads into waterways, numerous scenes of Cassiobury Park and the canal, together with countless views of our town.

A Postcard From Watford takes the reader on a journey back to a time when the pace of life was more tranquil than it is today, through the lovely parkland and about the town using a selection of fascinating old photographs and picture postcards, many of which have not seen the light of day for generations. Mostly messages were of mundane matters or informing a loved one of an impending visit, but sometimes they appear more poignant, as in the case of the card sent from a soldier about to depart for the First World War trenches in France.

Of added interest too are the plethora of advertisements that provide a wealth of detail on businesses and shops long since gone from our streets. We also witness some of the preparations taking place prior to the commencement of the Second World War and visit the small, pretty village of Hunton Bridge a short distance from Watford. Due mention is given to the Bathing Place on the River Colne in the shadow of the Five Arches railway bridge, a popular swimming venue for many a long, hot summer until its closure in 1936. A lot of the old images depicted have modern-day photographs accompanying them as a comparison to illustrate the numerous changes, sometimes out of all recognition, that have occurred in the intervening years.

Yet, despite the ongoing transformation that is gradually taking place with each passing year, we owe an enormous debt of gratitude to those early photographers. With their cameras, primitive when compared to today's sophisticated equipment, they braved the elements throughout the four seasons to provide us with a lasting pictorial legacy of Watford's heritage, as illustrated on the following pages by the use of the simple postcard.

John Cooper

Acknowledgements

I am grateful to the following for their assistance:

Laurie Akehurst, London Transport Museum; Sue Brandon, Abbots Langley Library; Revd Dr Geoffrey Calvert, St Michael's church; John Castle; Sarah Costello, Watford Central Library; Pat Denton, Watford Central Library; Dave Horton; Ellie Payne, Kings Langley Library; Ali Liaqat, Watford Junction Station; Roger Middleton, Curator, Hertfordshire Fire Museum; Michael A. Morant; Joan Perkins *née* Tearle; Sarah Priestley, Watford Museum; Jill Waterson, North Watford History Group; and Trevor Yorke.

I am indebted to Susan Flood, County Archivist; Pru King; Vanessa Lacey, Watford Central Library; A. D. Packer; Anne Petty, Watford Grammar School for Boys; Paul Rabbitts, Watford Borough Council; Fred Richardson; Dorothy Thornhill MBE, Elected Mayor of Watford; and Richard Walker, Watford Football Club, for their kind permission to use some of their photographs and/or material.

I am also indebted to Mary Forsyth, Watford Museum, for her helpful and constructive advice, and for giving me the benefit of her extensive local history knowledge.

Special thanks are extended to my wife Betty for her constant support, encouragement and valuable input; to my son Mark for his continuous IT support; and to my publishers for their kind assistance in producing this publication.

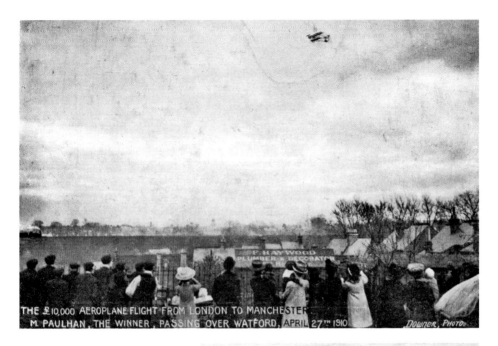

THE £10,000 AEROPLANE FLIGHT FROM LONDON TO MANCHESTER. M. PAULHAN, THE WINNER, PASSING OVER WATFORD, APRIL 27TH 1910. *Downer, Photo*

Excited crowds turned out to see the London to Manchester aeroplane race passing over Watford on 27 April 1910. The prize of £10,000 was offered by the *Daily Mail* to the first pilot to make the flight within twenty-four hours. The winner was French aviator Louis Paulhan, covering the distance of 195 miles in a time of twelve hours, thus beating the British contender Claude Grahame-White. (Advertisement courtesy of Watford Central Library)

FLYING!

The World-Famed Berkshire Aviation Tours beg to announce

PASSENGER FLIGHTS

From **5/-** Each

AT TOLPITS LANE

Near Watford West Railway Station,

WATFORD,

From AUGUST 21st to SEPTEMBER 2nd

INCLUSIVE.

Daring Exhibition of Crazy Flying

On SUNDAY at 4.15 and 7.45 p.m.

The Exhibition consists of Looping, Spinning, Rolling, and all the things that can be done on an Aeroplane by Experienced Pilots.

The B.A.T. has carried over 80,000 people safely, visited over 500 different towns, flown for six years (winter and summer), and in every town visited are known for their Safety First methods, and the pleasure given to their passengers. No stunting is given to ordinary passengers ; if you do want a few we can do them, but it will cost you a little more. The oldest passenger carried was Mrs. Ann Sissons, at the age of 103 (a world's record), and the youngest 3 years. We will carry anybody from 103 to 3, and everyone will enjoy the experience.

FLYING DAILY from 10 a.m. to DARK

3-SEATER MACHINES IN USE ALL THE TIME.

All Flights done on B.P. the British Petrol.

Admission to Field 6d.　　Children 3d.

WATFORD ! You will be under the earth one day. Get off it !

King & Hutchings, Ltd., Printers, Uxbridge.

5

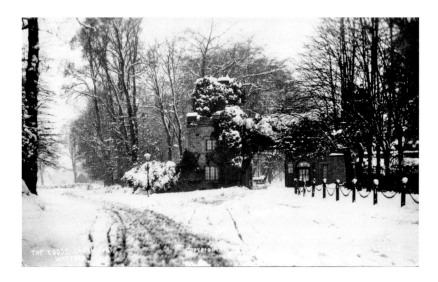

Above: This charming wintry scene in a rural looking Rickmansworth Road depicts what used to be one of Watford's well known local landmarks – the early nineteenth-century lodge gates leading to the beautiful Cassiobury Park and Mansion, the seat of the Earls of Essex. Sadly, on 24 July 1970 this picturesque edifice was reduced to rubble under a demolition order to facilitate a new road widening scheme.

Below: Intrigued by the presence of the photographer, these young people appear to be enjoying a stroll at the Rickmansworth Road end of Cassiobury Park, probably accompanied by the two adults shown near the fencing. At the turn of the nineteenth century, with the 7th Earl of Essex now living in London and despite considerable public feeling, 65 acres of this beautiful parkland were purchased in 1909 by Watford Urban District Council for the purpose of 'public walks and pleasure grounds', with a further 25½ acres being acquired three years later. Today, the award-winning park attracts numerous visitors from far and wide who come to enjoy the many amenities on offer and to stroll along the tree-lined avenues, just as those young people in the photograph below did over 100 years ago.

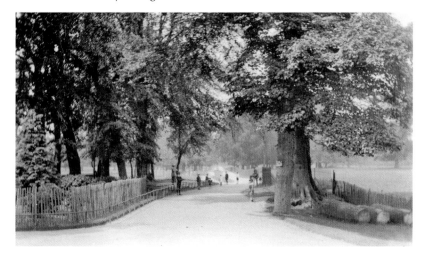

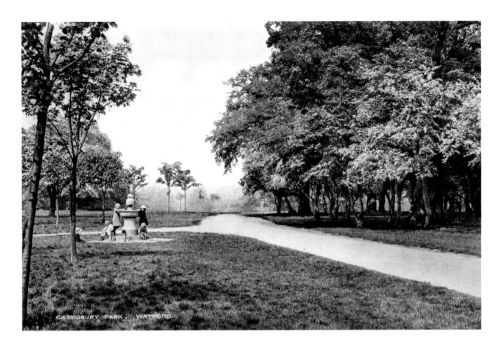

Enjoying a cool, refreshing drink of water on a hot, summer's day, these children are gathered round the fountain in Cassiobury Park near to the Pavilion Tearooms. For those with a musical ear, there was plenty on offer each Sunday afternoon from the fine Edwardian bandstand just out of camera shot on the right where, for the price of a deckchair, one could sit and listen to the band playing the popular melodies of the day. Although the fountain has long since gone, the view has barely changed in over eighty years, as can be seen in the photograph below, taken in 2012.

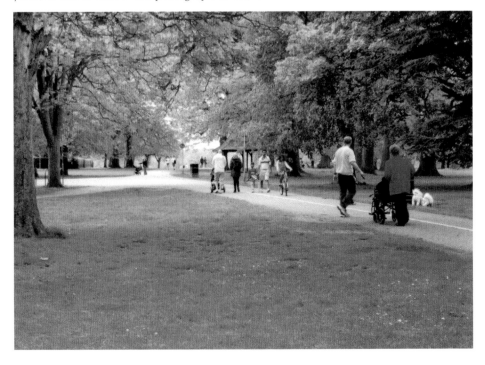

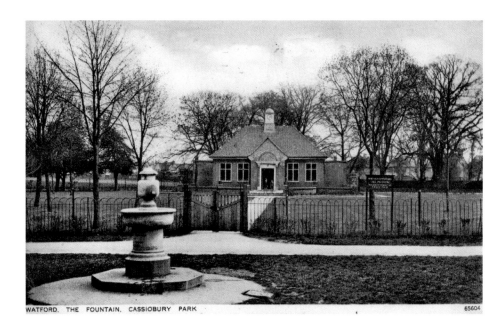

WATFORD, THE FOUNTAIN, CASSIOBURY PARK 65604

Postmarked 7 November 1929, this Real Photo picture postcard shows another view of the Cassiobury Park fountain with the Pavilion Tearooms in the background. Both features were constructed during the 1930s and although the fountain was removed sometime after the mid-1960s, the tearooms remain. Today they are the popular Cha Cha Cha Café, which throughout the year provides an invaluable service to all who visit our lovely park.

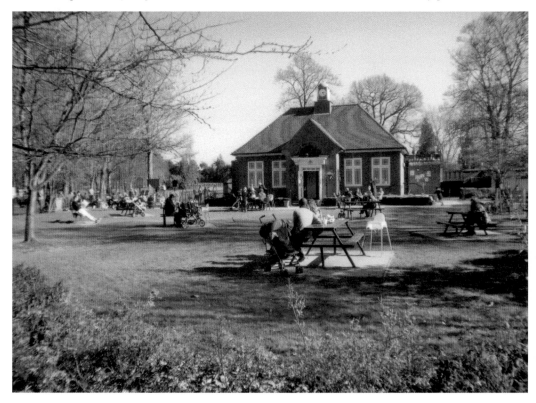

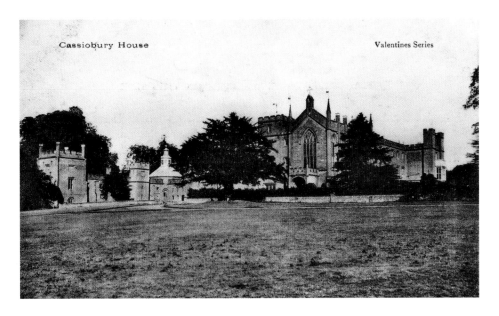

Photographed in the early part of the twentieth century, it is difficult to imagine that this magnificent mansion would eventually be razed to the ground. Although the estate was sold privately in 1922 for building development following the death of the 7th Earl, George Devereux de Vere Capell, in 1916, the house was left empty and unused for a further five years until, without a purchaser, a decision was made in 1927 for the property to be demolished. The ornate Grinling Gibbons main staircase of Cassiobury House (seen below) was carefully removed and is now in the Metropolitan Museum of Art in New York. (Bottom picture courtesy of Watford Central Library)

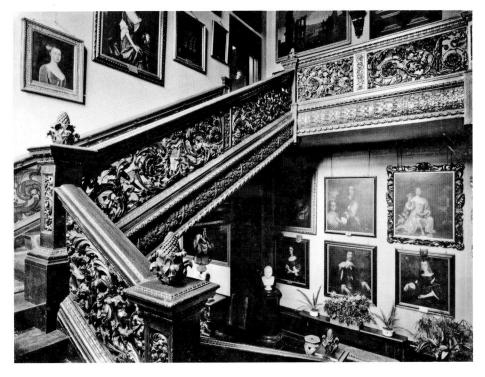

Following demolition, a sale of building materials took place on site on Wednesday 9 November 1927. (Bottom advertisement courtesy of Watford Central Library)

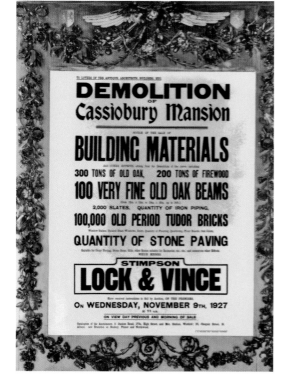

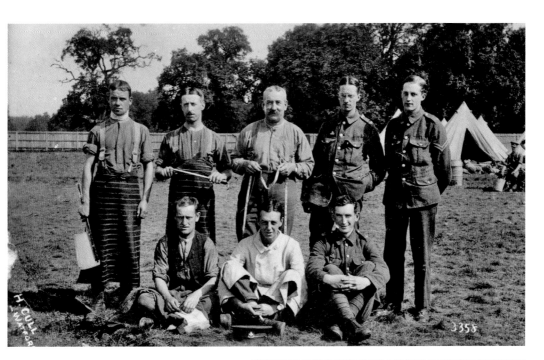

This interesting card by local photographer Harry Cull is postmarked 23 August 1915 and was sent to a Miss G. Wells of Worksop. The message written was 'Dear Gladys, How do you like it – the Quartermaster's staff? What about the central figure eh what! I heard you knew someone in the R.F.A. (Royal Field Artillery). Is it true?' The fact that two of the soldiers are holding a cleaver and sharpening steel indicates that they could be part of the butchery section of the camp kitchens, although it is not apparent what the significance is of the tape measure being held by the splendid looking chap in the middle. On Wednesday 4 August 1915, the first anniversary of the declaration of war with Germany, meetings and parties were held throughout the country. One of these events was the Watford Habitation of the Primrose League in the Cassiobury grounds, kindly lent by the Earl of Essex. Juvenile sports were played, after which prizes were presented by the Countess of Clarendon. The Primrose League was an organisation for spreading Conservative principles in Great Britain and was founded in 1883.

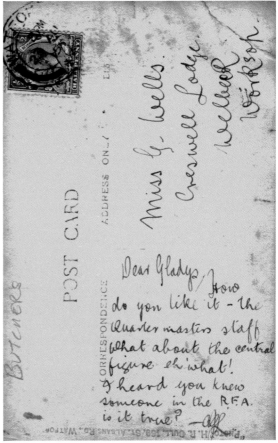

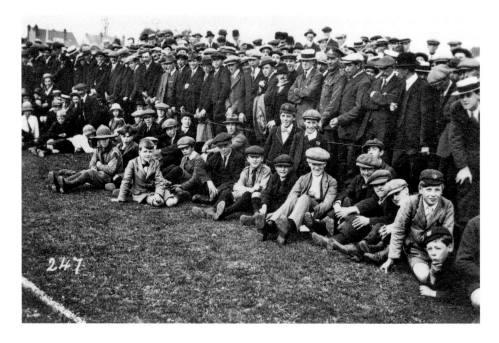

Although over 100 years separates these two images, the spectators in the top picture look as though they are thoroughly enjoying a sporting event in Cassiobury Park, probably not too dissimilar from the 10K Run depicted below on 2 May 2011.

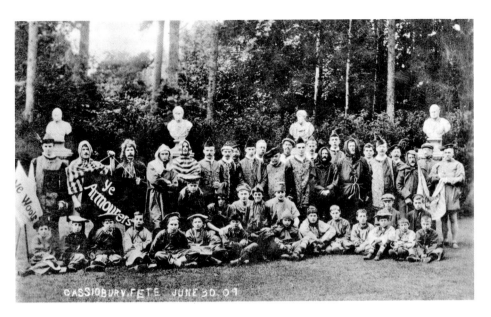

Over the years, Watford's Cassiobury Park has played host to numerous events and activities ranging in diversity from fêtes such as the one shown above in June 1909, where the participants are dressed in an assortment of period costume, the exciting Peace Celebrations of July 1919 following the end of the First World War, the annual Whitsun Carnivals and various sponsored runs, to name but a few. With thousands of visitors to the park each year, one of the many attractions now on offer is the children's paddling pool complex seen below on a fine sunny day in 2012. Constructed in the early 1980s, the pools, together with a refreshment kiosk and a revamped play area provide many hours of pleasure to countless youngsters throughout the long summer holidays. The arrival of the fun fair provides much excitement too, with white-knuckle rides such as Twister, Midnight Express and the Wild Mouse rollercoaster, all guaranteed to pump the adrenaline of most thrill-seeking teenagers.

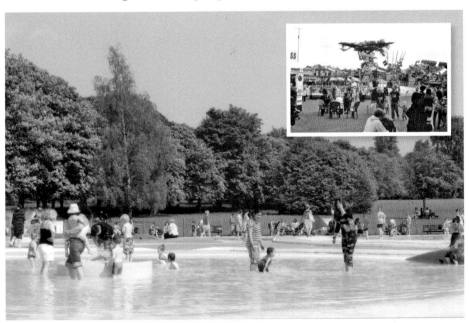

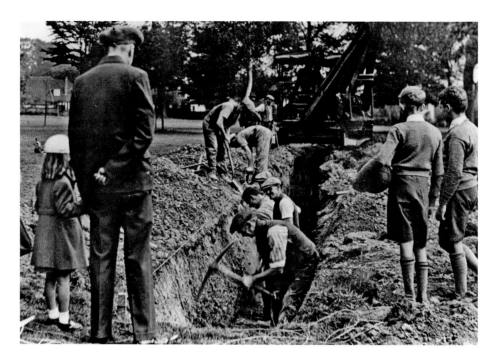

With the storm clouds of war gathering in that late summer of 1939, these young children are watching some workmen digging trenches in Cassiobury Park. Probably memories of the First World War conflict twenty years earlier are rekindled by the little girl's grandfather as preparations are made in Watford and all over the country for a possible enemy invasion. The bottom picture shows the delivery to a local resident of the curved metal sections that, when bolted together, formed the Anderson air-raid shelter which was erected in people's gardens as a small and inexpensive form of protection in the event of aerial bombing by the German Luftwaffe. (Pictures courtesy of Watford Central Library)

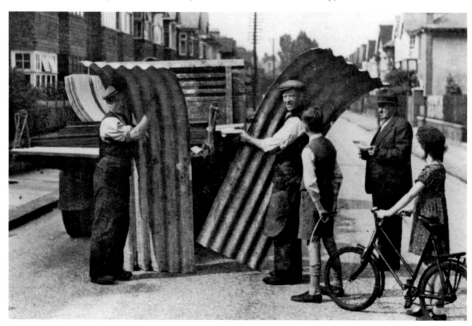

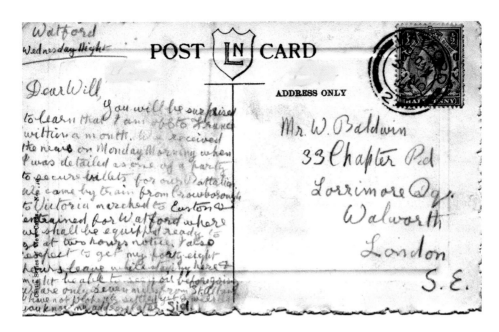

Above: Postmarked 5 November 1914, the message to Mr W. Baldwin of Walworth, London, must have been one of thousands of such sentiments sent to friends, family and loved ones from soldiers awaiting the fateful posting to the First World War trenches just across the Channel: 'Dear Will, You will be surprised to learn that I am off to France within a month. We received the news on Monday Morning when I was detailed as one of a party to secure billets for our Battalion. We came by train from Crowborough to Victoria, marched to Euston & entrained for Watford where we shall be equipped ready to go at two hours notice. I also expect to get my forty-eight hours leave while staying here and might be able to see you before going. We are only seven miles from St. Albans. I have not properly settled yet & will let you know my address later. Sid.'

Right: The message on this somewhat cryptic undated postcard reads: 'Down the lane I met about 20 cows. Oh dear. I halted in a field till they has (sic) passed. I don't like rushing through cattle, how are you dears we had a nice weekend at the Cottage. I sent a card from S. Chart, hope you get it safely let me know if you do. Shall be cycling to Chorleywood on Tuesday "quite alone". I want to see the old spot again where you and I had some fun. My fondest love from Doll.'

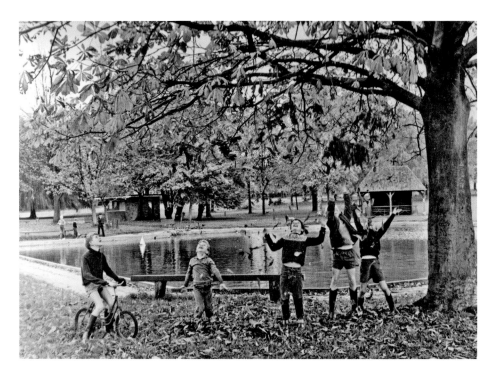

Constructed in 1933, the paddling pool, where many a happy hour was spent by the local youngsters splashing in the cool water or sailing a toy yacht, was eventually filled in and grassed over in the early 1980s when the new paddling pool complex was completed a short distance away. The young lads above could be trying to catch the falling leaves or, more probably, attempting to gather the spiky horse chestnuts for the time-honoured annual tradition of playing conkers. Today, the route of the popular miniature railway passes over the tree-lined site where the old paddling pool used to be. (Top picture courtesy of Watford Central Library)

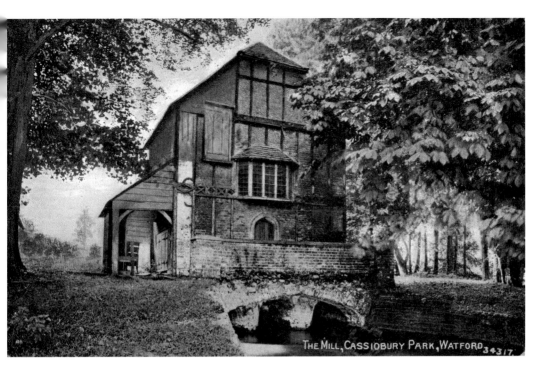

The Mill, Cassiobury Park, Watford 34317

Originally used for the grinding of corn and later utilised to pump water to Cassiobury House, the Old Mill situated near the weir at the bottom of the park, adjacent to the canal, fell into disuse following the demolition of the mansion in 1927. The dilapidated structure was eventually knocked down and removed in 1956, although the arched foundations over the mill stream are still visible today.

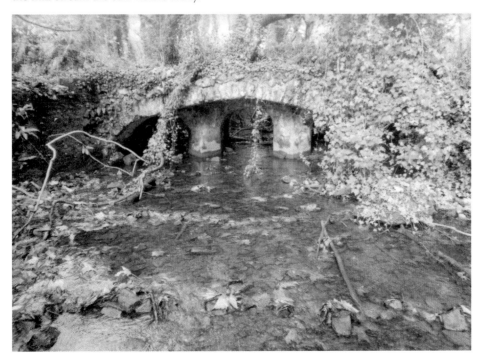

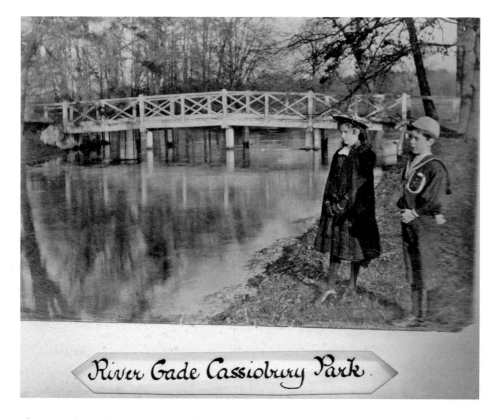

River Gade Cassiobury Park.

This snapshot taken at the turn of the nineteenth century shows two children posing for the photographer at what is now known as the Rustic Bridge. Although the structure of the bridge may have altered over time, this peaceful spot by the River Gade at the bottom of Cassiobury Park remains virtually unchanged. The river, which is very shallow at this point, attracts numerous youngsters during the hot, lazy days of summer when, armed with fishing net and jam jar, they attempt to catch the ever-elusive minnows in the clear water.

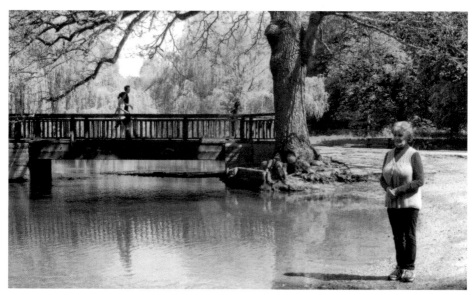

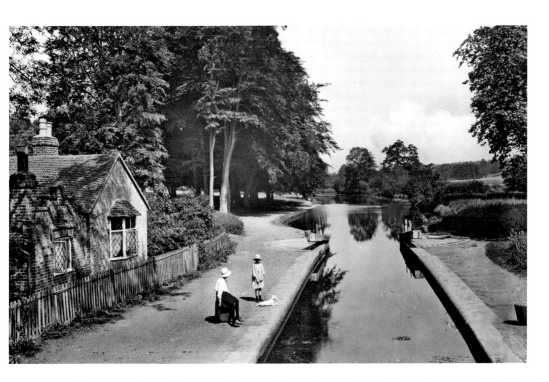

Dating from around 1921, this tranquil scene of Cassiobury Park's Iron Bridge Lock (No. 77) and cottage contrasts considerably with the modern-day view taken from the adjacent Bridge No. 167, which during the summer months attracts a great many visitors to watch the narrowboats passing through the lock. The cottage was demolished during the late 1920s or early 1930s.

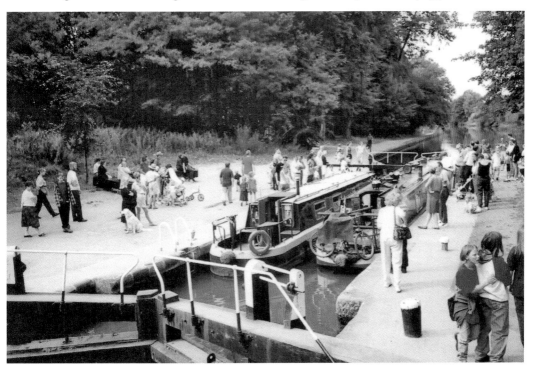

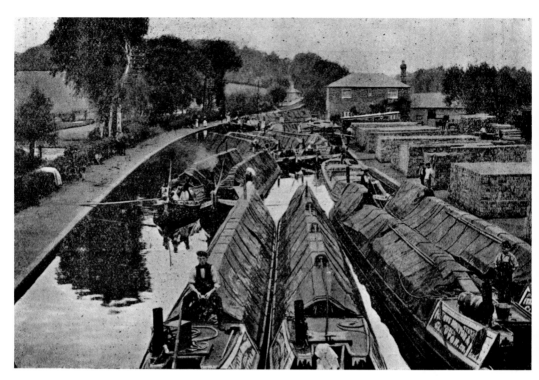

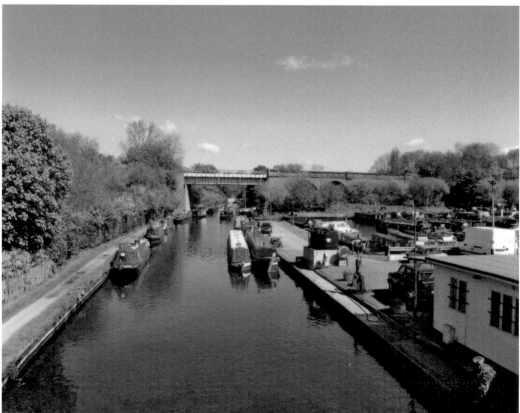

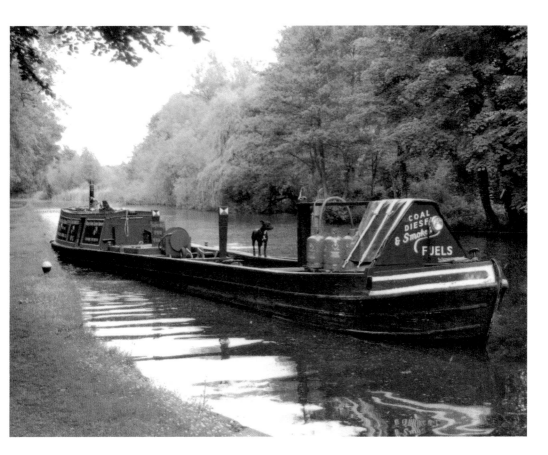

Opposite page, top: Taken from Cassio Bridge in the early part of the twentieth century, well before the construction of the Watford branch of London Underground's Metropolitan Line, the photograph shows narrowboats being loaded with their cargo of timber from the wharfside before being taken up the waterway for use as pulp in the local paper mills.

Opposite page, bottom: With the decline of the working narrowboats and the increasing popularity of pleasure craft, the marina today offers a range of high-class services for the boating enthusiast, such as maintenance and servicing, providing water and fuel, undertaking pump-outs and arranging moorings.

Above: There are also several supply narrowboats that travel up and down the cut, as the canal is sometimes called, providing the moored boaters with essential and exceedingly welcome replacement stocks such as diesel fuel, gas canisters and bundles of firewood.

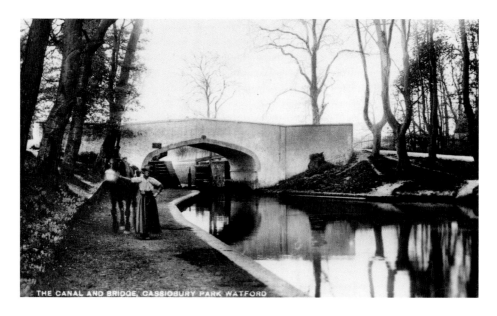

THE CANAL AND BRIDGE, CASSIOBURY PARK WATFORD

Pictured near the Iron Bridge Lock in Cassiobury Park, this unused card shows a woman, possibly of Afro-Caribbean origin, holding the harness of the tow horse. Dressed in a white blouse, long skirt and floppy hat, it is not known whether the woman was the boatman's wife or someone employed to help look after the horse while it was towing. The nose tin attached to the horse's mouth allowed it to feed without stopping. The narrowboat would be just out of camera shot. One of the main obstacles that confronted the boatmen on a journey up and down the canal system were the tunnels. The horse had to be unhitched and led over the hill to rejoin the towpath on the other side, while two men lay on their backs with their feet on the surface of the roof and literally 'walked' the boat through the tunnel. This was known as 'legging' and was a hard and arduous experience, especially as the only light was that provided from a flickering candle.

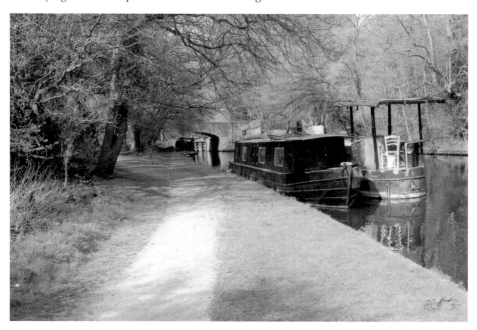

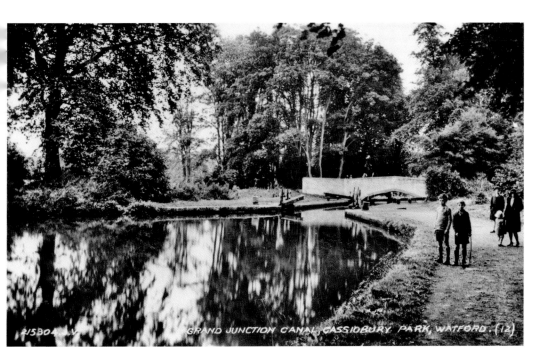

Although posted on 24 November 1936, this picture postcard of the Iron Bridge Lock was probably taken during the late 1920s when the Grand Junction Canal was purchased by the Regents Canal in 1927 and amalgamated with other companies to form the Grand Union Canal in 1929. Over eighty years later, this peaceful scene remains largely unchanged.

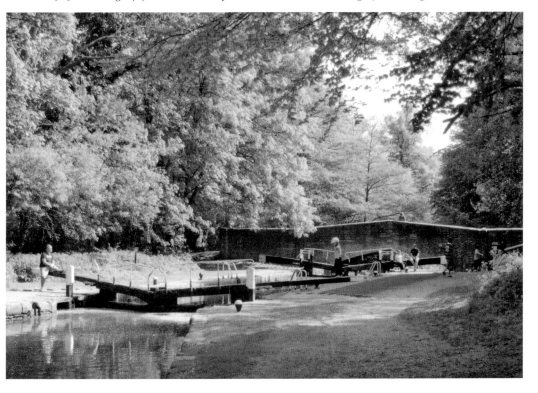

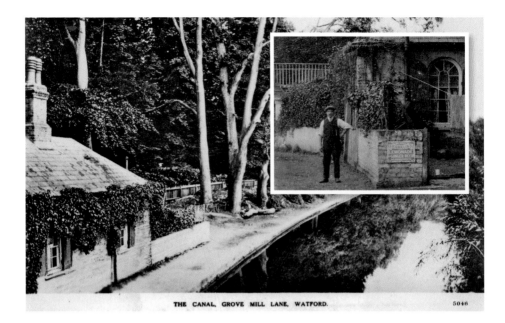

THE CANAL. GROVE MILL LANE. WATFORD. 5048

Photographed from Grove Mill Bridge (No. 165) in Grove Mill Lane, this charming waterside dwelling called Canal Cottage was built in the early nineteenth century by the Grand Junction Canal Company as accommodation for one of their employees, whose job it was to collect tolls from passing narrowboats. From around 1910 to 1930, the cottage was occupied by Fred and Rosa Tearle and their two children. At one time Rosa ran the premises as a small tearoom – certainly a lovely setting to sit and enjoy a cool, refreshing drink. The sign on the garden wall of the cottage, as seen inset above, advertises the sale of 'Franklin's Lemonade and Ginger Beer'. At the time the bottom picture was taken the cottage was in the process of being renovated.

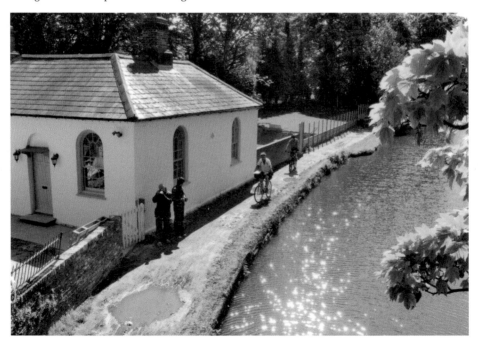

GROVE MILL LANE. WATFORD. 34.

It is difficult to imagine that a short distance away at the top of leafy Grove Mill Lane is the busy A411 Hempstead Road into Watford. Just out of camera shot behind the photographer in this quiet location is Grove Mill which was built in 1875 to produce flour for the Grove Estate, family seat of the Earls of Clarendon. Following a complete renovation, the old mill was converted into flats during the early 1970s.

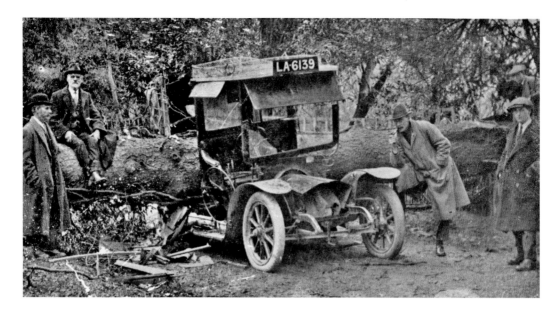

Along with many other parts of the country, on Tuesday 28 March 1916 Watford and south-west Hertfordshire experienced the full fury of what was called the Great Storm, where gale force winds caused nearly all of the roads leading out of Watford to be blocked with falling trees. Stalls were blown down in the market place and Lower High Street, as has so frequently happened before, suffered from extensive flooding. In Grove Mill Lane, a taxicab belonging to the Clarendon Garage in Station Road had to pull up because of a falling tree, only for another one to crash onto the cab, cutting the motor car in two. The driver and two lady occupants were indeed fortunate in managing to escape as the tree was falling.

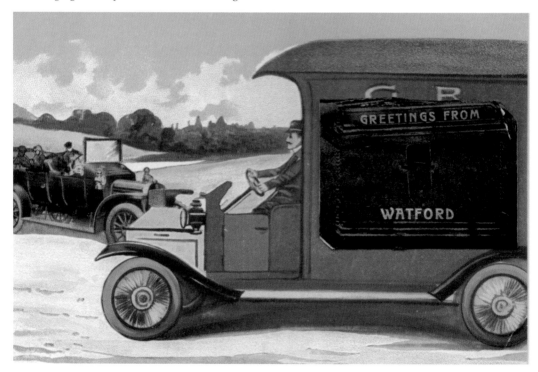

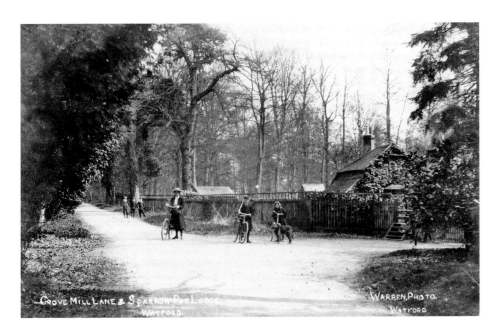

The Real Photo picture postcard above and the snapshot below were both taken in the early 1900s and show the delightful Sparrowpot Lodge set in Whippendell Woods on Grove Mill Lane. It was one of the entrances to the extensive Cassiobury Estate belonging to the Earl of Essex. Both dwellings have long since been demolished, with the area now a secluded car park, a stopping off place where visitors can explore the many lovely woodland walks.

27

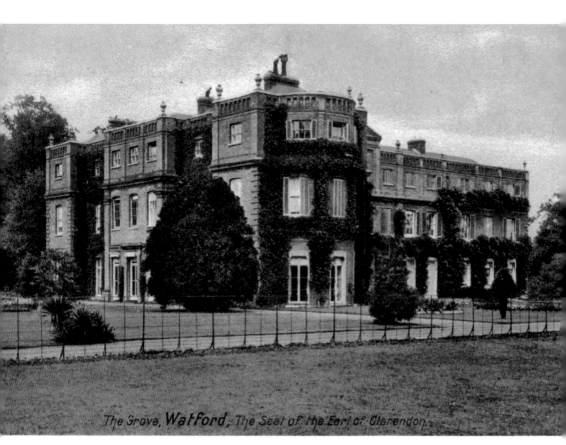

The Grove, Watford, The Seat of the Earl of Clarendon.

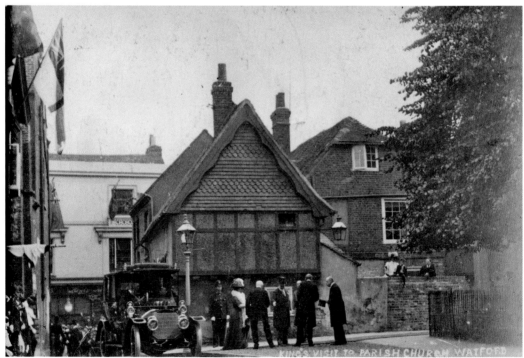

KING'S VISIT TO PARISH CHURCH WATFORD

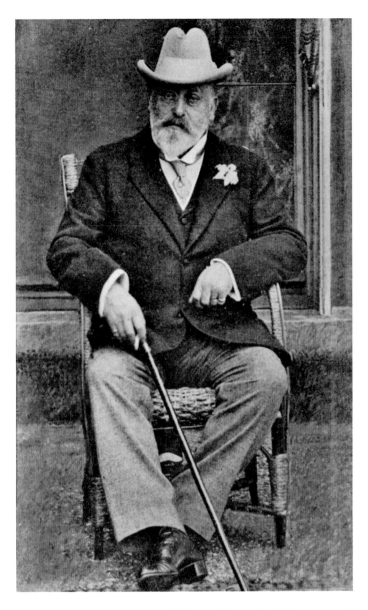

This imposing mansion, The Grove, set in the beautiful Hertfordshire countryside, was once the ancestral home of the Earls of Clarendon. It was here that many fashionable weekend parties were held, one of the most important guests being King Edward VII (seen above) who made a short 'Saturday to Monday' visit to The Grove on Saturday, 17 July 1909, attending Divine Service at St Mary's church the following day. The King's limousine can be seen opposite parked outside the One Bell public house with the royal party preparing to enter the church. However, in 1922 the Clarendon family's long association with The Grove ended when the estate was sold by the 6th Earl, George Herbert Hyde Villiers, who had decided to move to Hampstead in London. For a while, a high class girls' school occupied the premises until, at the outbreak of the Second World War, the London, Midland & Scottish Railway (LMS) acquired The Grove for the duration, moving their headquarters from London. Following the cessation of hostilities in 1945 and several changes of occupancy over the years, The Grove now enjoys a resurgence as a prestigious hotel, spa and golf course.

The message on this unstamped postcard reads: 'Dear Glad, Thank you very much for your nice letter, also snaps. Tell Mum I reckon she came out alright – I mean that one on the boat with Arthur and Win peeping through. I thought she couldn't have had her teeth in but Dad said she had – the group she comes out in is ever so good. Yours with love, Auntie.'

Dated 7 September 1911, the message reads: 'Dear Ethel, I am glad you are having such a nice time. You knew how to arrange it. We have stayed on every night this week & are staying tomorrow. If they say we are to stay on Saturday, we are going to walk out. Love from Lillie.'

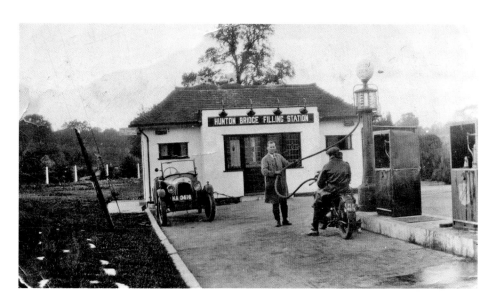

This lovely old photograph, probably from the mid-1920s, shows the Hunton Bridge Filling Station, just a short distance from The Grove, at a time when the pace of life was more tranquil and traffic-free than it is today, and the price of petrol was only about 1*s* 5*d* a gallon. Situated where Old Mill Road, just to the right of the garage, meets the A41, the petrol station has changed out of all recognition when compared to the earlier image; only to be expected after over eighty years. The car is a Citroen C2 known in France as the *Trèfle* (Cloverleaf), also commonly known as a 5CV and was produced between 1922 and 1926. It may well have been one of the original models to be produced at Citroen's first overseas factory in Slough. It is interesting to see that the attendant, no doubt justifiably proud, is using one of the new Fry 'guaranteed visible measure petrol pumps', where the amount of fuel selected filled a transparent glass bowl. The motorist could then check to see that the number of gallons being dispensed and the particular grade, denoted by the colour of the petrol, was what had been requested.

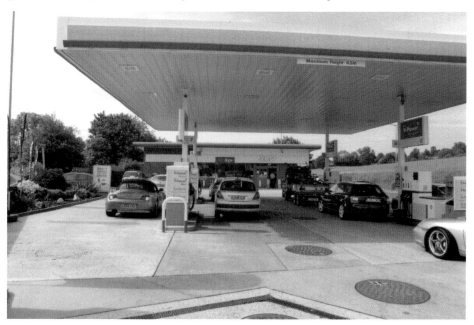

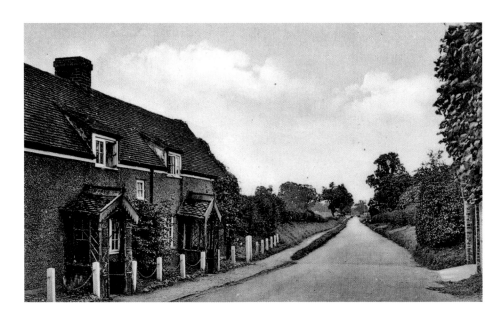

Photographed in the early 1930s, this unused postcard shows the picturesque Riverside Cottages in Old Mill Road, once part of the original Sparrows Herne Turnpike Trust route in the early nineteenth century. Coaches used to run from Bushey Heath to Aylesbury via Watford, Hunton Bridge and Hemel Hempstead. In the distance, just out of camera shot, is the Hunton Bridge filling station, while the small village of Hunton Bridge lies in the other direction, at the end of this quiet country lane.

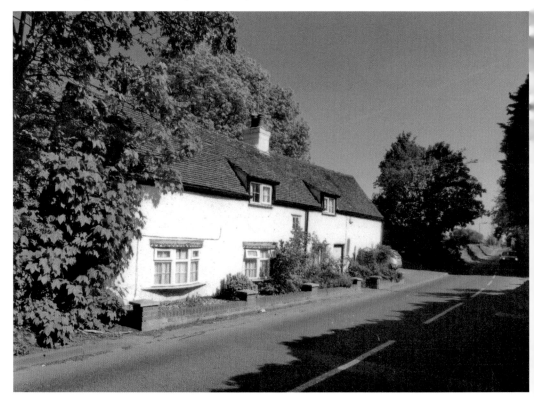

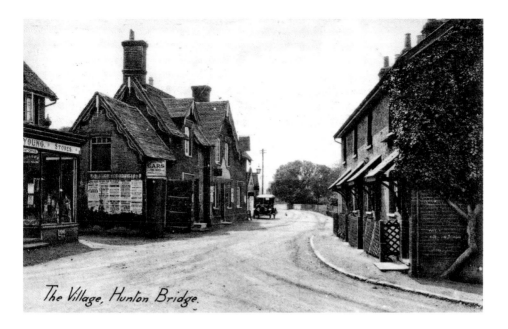

The Village, Hunton Bridge.

This attractive 1925 postcard shows Old Mill Road with the Dog & Partridge public house, where the landlord in 1933 was George Alfred Allen, Quelch's Yard, and Frank Young's post office and general store on the extreme left of the photograph. Motorists travelling towards Watford along Old Mill Road could stop and fill up with petrol at the Hunton Bridge filling station at the other end of the lane. The Dog & Partridge continues to thrive to this day.

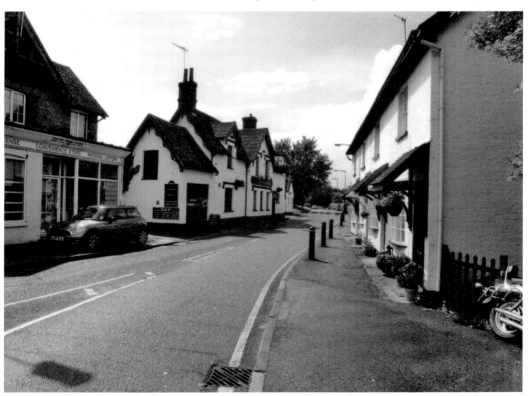

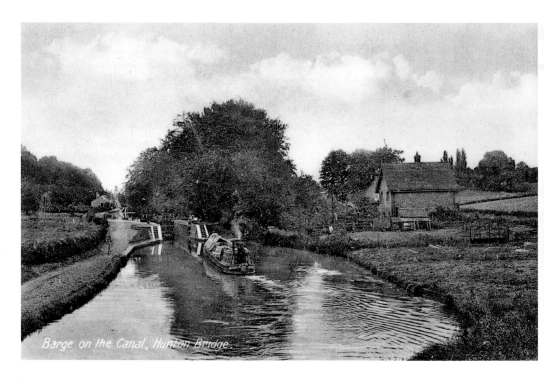

Barge on the Canal, Hunton Bridge.

Time seems to have stood still when comparing the two earlier images of Hunton Bridge Lock with those taken in 2012. The above picture shows a narrowboat with its cargo approaching Lock 73 (Bottom Lock) while the photographs on the opposite page depicts the lockkeeper's cottage at Lock 72 (Top Lock).

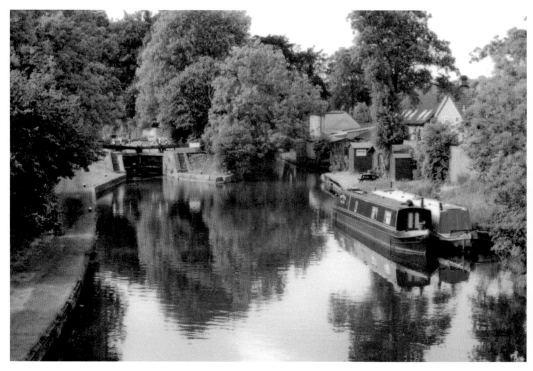

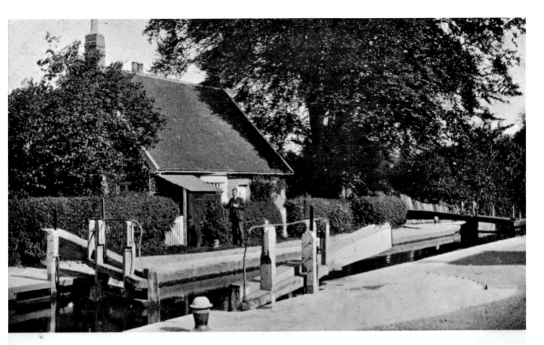

The Lock, Hunton Bridge.

Both locks are only a short distance from each other. Local directories indicate that the lockkeeper from around 1935 to 1952, possibly a little longer, was one Charles Goodman.

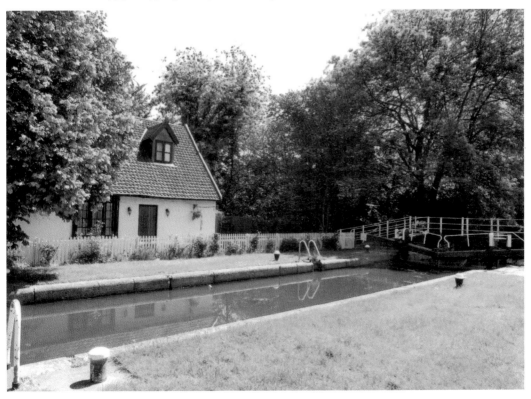

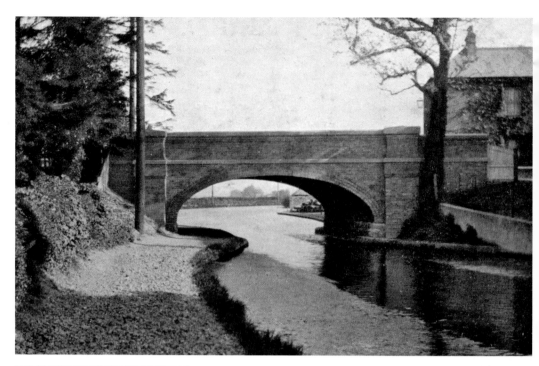

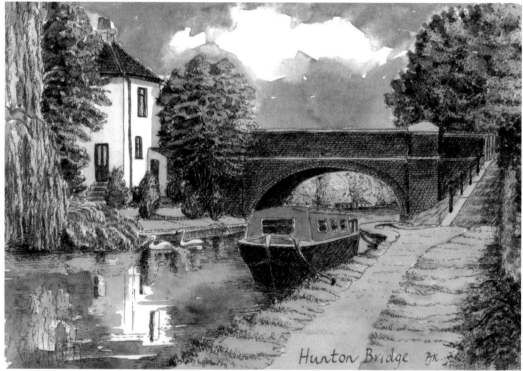

Hunton Bridge

(Picture courtesy of Prue King)

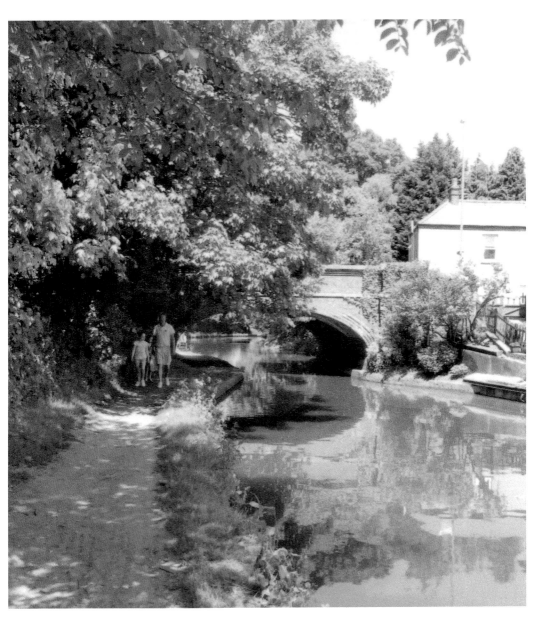

Following repairs in 1902, the Bridge Road canal bridge (No. 162), top left, was completely rebuilt in 1904. Like most of this stretch of inland waterway in south-west Hertfordshire, there are many pretty walks along the towpath, as seen in the 2012 view above taken on a fine, sunny summer's day. The bottom left image is a lovely pen-and-ink drawing overlaid with a watercolour wash by local artist, Prue King, and shows a picturesque scene on the other side of the canal bridge.

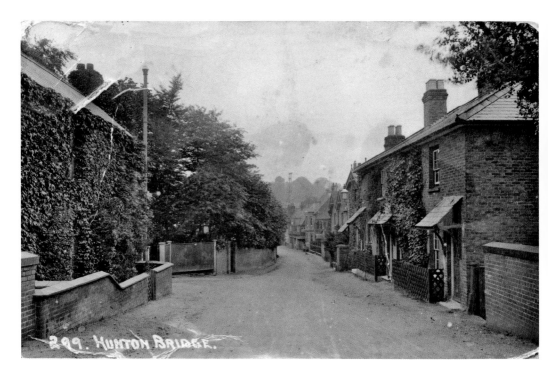

Although almost ninety years separates these two images of Hunton Bridge looking down Bridge Road from the canal, outwardly the scene looks almost as though time has stood still. The white building at the end of the street, in the centre of the picture below, is the King's Head public house, a charming 300-year-old Grade II listed building that was once a coaching inn in the days when the Sparrows Herne Turnpike ran through the village.

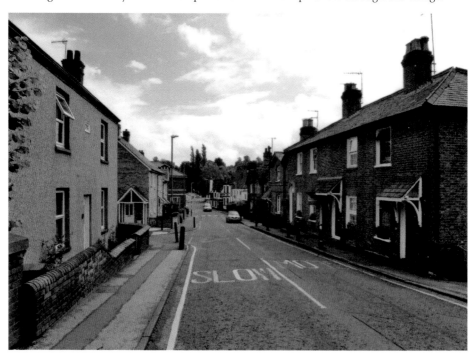

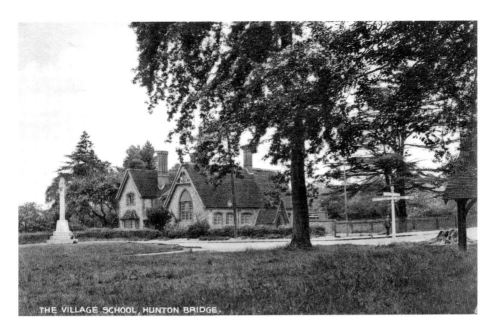

THE VILLAGE SCHOOL, HUNTON BRIDGE.

Built in 1858 by the squire William Jones Loyd, the attractive Langleybury Church School served the community of Hunton Bridge for over 100 years on its present site. Here local children were taught to read and write and received religious instruction. Although school fees were charged in the early years, this was only at a very nominal amount and was abolished in 1891 when Langleybury became a Free School. Following an accident in 1890 where two children had fallen into the nearby Grand Junction Canal, a new rule made the canal out of bounds; any child breaking this rule received several strokes of the cane. With the widening of the busy A41 in 1966, a new Church of England primary school, now known as St Paul's, was constructed a short distance away in Langleybury Lane. It opened on 8 March 1967. Today, known as The Old School House, the original school building is now enjoying a renaissance as prestigious office accommodation.

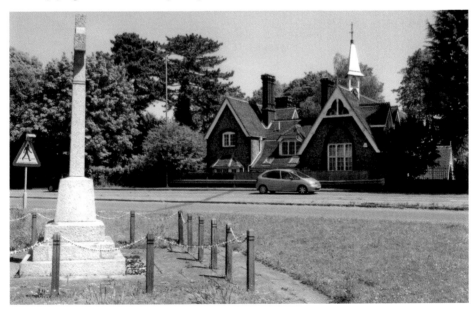

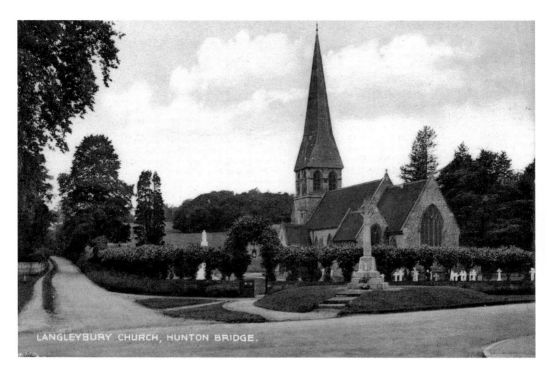

LANGLEYBURY CHURCH, HUNTON BRIDGE.

The lovely St Paul's church, with its distinctive 130-foot oak-shingled spire, was constructed in 1864, paid for by the squire, London banker William Jones Loyd, who had purchased Langleybury House and its estate in 1856. For fourteen years, the church remained a chapel of ease to St Lawrence in Abbots Langley until it gained its own parish in 1878.

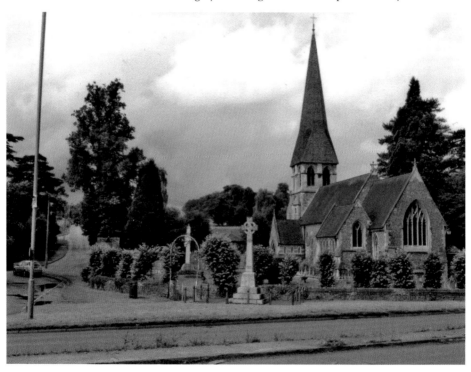

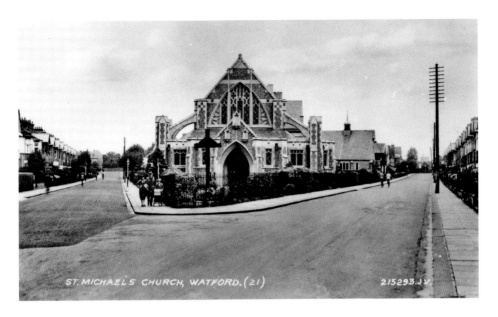

The distinctive looking church of St Michael's, seen here in this unused early postcard, occupies a prime position on the corner of Mildred Avenue and Durban Road West. With the rapid expansion of the population in Watford, brought about by the railways and other major industries, plans were drawn up at the beginning of the twentieth century for a new church to be built to serve the spiritual needs of the growing community in the west of the town. The enthusiasm and initiative for such a major project was largely attributed to two people: Canon Walter Littlebury and Alice 'Mildred' Schreiber. The church, dedicated in 1905, was used as St Michael's Hall following the consecration of a new larger building on 19 Januray 1913. St Michael's became the focal point for both worship and social life. Now the church is in partnership with the West Watford Free Church and the Christian presence in the area remains just as strong today as it did 100 years ago.

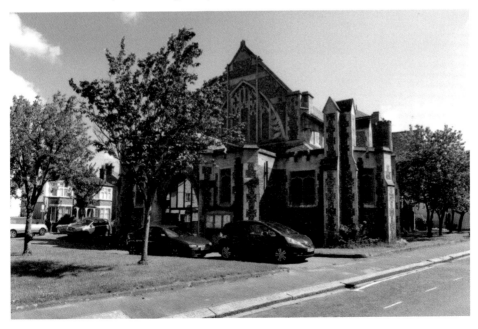

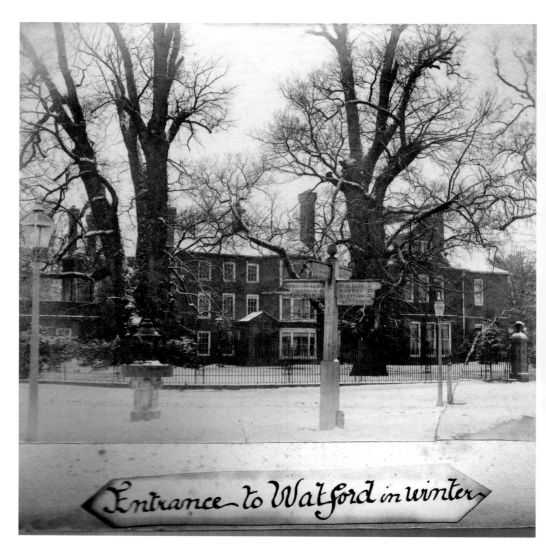

This old snapshot, taken during the late 1890s or early 1900s, shows a wintry scene at the Crossroads, the junction where Hempstead, Rickmansworth and St Albans Roads met with the High Street. Up until the mid-1930s, control of converging traffic at this point had been carried out by an AA patrolman, but with the ever-growing volume of cars and other vehicles this task was becoming increasingly difficult and the decision was taken to build a roundabout. The building in the background is The Elms, an early eighteenth-century mansion that was later demolished in preparation for the construction of the new town hall that was officially opened on 5 January 1940.

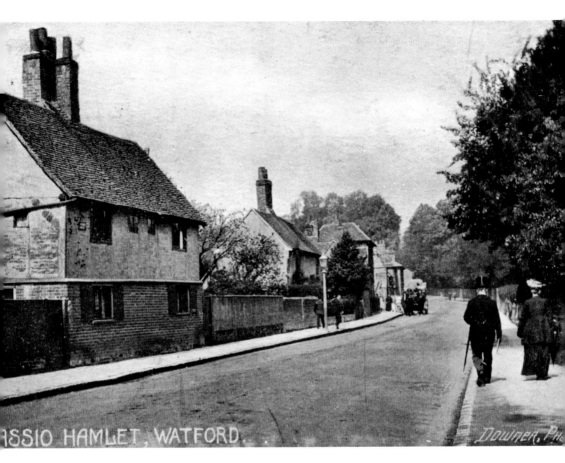

CASSIO HAMLET, WATFORD. Downer, Ph.

This Edwardian image of Cassio Hamlet by local photographer Frederick Downer was sent as a postcard on 19 February 1906 to a Mr Arthur Beaumont of Berkhamsted. The area illustrated, just north of the Crossroads, consisted of a small cluster of cottages and two public houses, The Dog and The Horns, both well frequented by carters passing through the hamlet with their horse-drawn haywains on their way to the weekly livestock market in the centre of Watford. Today, although the cottages and The Dog have gone, The Horns remains, enjoying considerable recognition as a live music venue. No longer a country lane, the thoroughfare, which is now pedestrianised, is home to Watford Central Public Library, opened in 1928. Further along the road are West Herts College and the modern swimming pool complex, Watford Leisure Centre, Central.

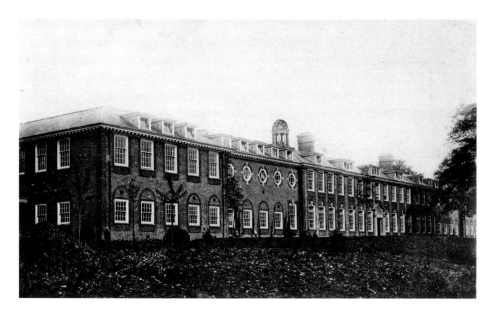

This unused Real Photo postcard shows the Watford Grammar School for Boys, probably taken shortly after the move from Derby Road. Its origins can be dated as far back as 1704 when Dame Elizabeth Fuller founded the Free School, a charity 'for the teaching of forty poor boys and fourteen poor girls of Watford in good literature and manners,' on ground adjacent to St Mary's parish church. Following the school's closure in 1882, the establishment was transferred to new premises in Derby Road called the Endowed School. The building for the boys' school was opened by the Earl of Clarendon on 21 April 1884 with those for the adjoining girls' school opening a day later. However, by the turn of the century, with the accommodation now far too small to cater for the steady increase in pupil numbers, a large, modern development in Shepherds Road was opened in 1912, again by Lord Clarendon. The large green building to the left of the bottom picture is the Clarendon Muse, home of the prestigious Watford School of Music.

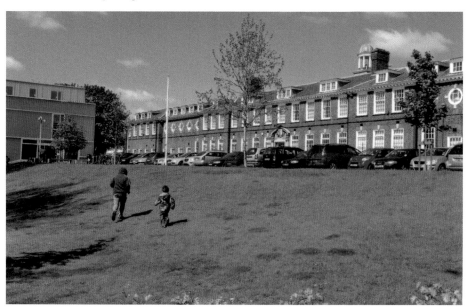

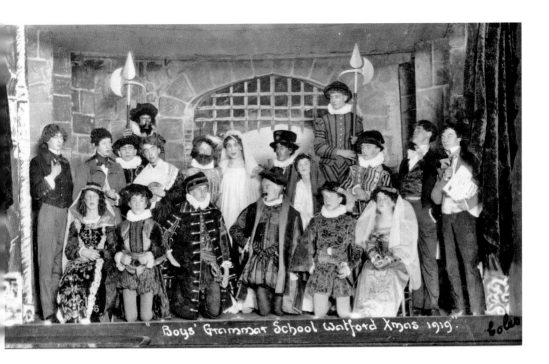

Boys' Grammar School Watford Xmas 1919. coles

The carefully posed picture above of the Watford Grammar School for Boys' School Dramatic Society was taken by local photographer, William Coles, in 1919 and shows the cast in an end of Christmas term play, a satire called *The Critic or A Tragedy Rehearsed*, by Richard Brinsley Sheridan. All the profits from the three performances on Wednesday 17 December and Thursday 18 December, which were reported as being 'an unqualified success,' raised the handsome sum of £28 16s 3d, which was donated to the Watford Memorial Hospital. *The Critic* was first performed at the Drury Lane Theatre in London on 29 October 1779 and was intended to pour ridicule upon the absurd conventions of the tragic stage. Many of the scenes were parodies of actual contemporary dramas. (Programmes this page and next courtesy of Watford Grammar School for Boys)

WATFORD GRAMMAR SCHOOL FOR BOYS.

SCHOOL DRAMATIC SOCIETY.

"The Critic"
or
A Tragedy Rehearsed

By
RICHARD BRINSLEY SHERIDAN.

WEDNESDAY and THURSDAY,
2.30 p.m. and 7.30 p.m. 7.30 p.m.
DECEMBER 17th and 18th, 1919.

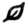

PROGRAMME
Price - Threepence.

All Profits will be handed over to the Watford Memorial Hospital.

"Our true intent is all for your delight."

45

"The Critic,"

By

Dramatis Personae.

(Arranged in the order of entrance upon the stage.)

Mr. Dangle	S. J. PRATT
Mrs. Dangle	B. C. PICTON
Sneer (the Critic)	G. E. PITTS
Puff	C. W. GRIBBLE
Under Prompter	E. F. BOIVIE

Characters in the Tragedy, The Spanish Armada:

Sir Christopher Hatton	P. J. PHILLIPS
Sir Walter Raleigh	G. D. A. BAKER
Earl of Leicester	L. H. FOWLER
Governor of the Tower	J. V. ASHBY
Master of the Horse	D. G. CHILTON
Sentinels	{ H. H. ECCLES / F. H. BAILEY
Tilburina (daughter of Governor of the Tower)	L. P. BONNET
Confidant	L. G. LOWRIE
Whiskerandos (a prisoner, son of the Spanish Admiral) ...	W. R. BALES
Beefeater	L. F. GIBBON
Burleigh	A. R. WATSON
1st Niece	C. J. S. MITCHELL
2nd Niece	C. E. THWAITES

Dresses by Messrs. C. H. Fox, 27, Wellington Street, London.

Scenery painted at the School under the direction of Mr. H. B. Withers, A.R.B.A.

Stage Manager	MR. W. HULME.
General Manager	MR. H. HAMMETT.

Synopsis of Scenery.

Act I.	...	Dangle's House.
Act II.	...	The Stage of Drury Lane Theatre.
Act III.	...	The Stage of Drury Lane Theatre.
Epilogue	...	written by L. P. Bonnet.

Incidental Music by the School Orchestra.

Conductor : MR. VICTOR DUANE.

Overture	"Slave Dance"	Henry.
First Entr'acte	...	"Suite for Strings"	Couperin.
Second Entr'acte ...	(a)	"In the Moonlight"	Ketelbey.
	(b)	"Caprice de Polichinelle"		...	Baratoff.

"The Critic" was first produced at Drury Lane Theatre on October 29th, 1779. The play was intended to pour ridicule upon the absurd conventions of the tragic stage. Many of the scenes are actual parodies of the contemporary drama.

47

Above: Pictured on 23 June 1934 in the forecourt of Watford Metropolitan Station, London Transport omnibus YU 2974, a twenty-six-seat bus operated by a two-man crew, was new to the Metropolitan Railway in 1927, but when it was decided that it was not in the Metropolitan's power to run a bus service it was passed to the Lewis Omnibus Company of Watford in November 1929. The Metropolitan had a financial holding in Lewis. The London Passenger Transport Board (LPTB) acquired Lewis on 1 October 1933 and the bus was then repainted in the first Country Bus livery of green and black. Its route as No. 315 was from Watford Metropolitan Station to Abbots Langley, via Watford West and Garston. The frequency was every ten minutes to the Three Horseshoes public house in Garston, with alternate buses continuing to Abbots Langley. The bus was withdrawn in April 1936. (Photograph by the late D. W. K. Jones, courtesy of A. D. Packer)

Left: Bucks Express, a coach company based on The Parade, was started in 1929 and ran a half-hourly service from Watford to London until it was acquired by Green Line in 1932. (Advertisement courtesy of Watford Central Library)

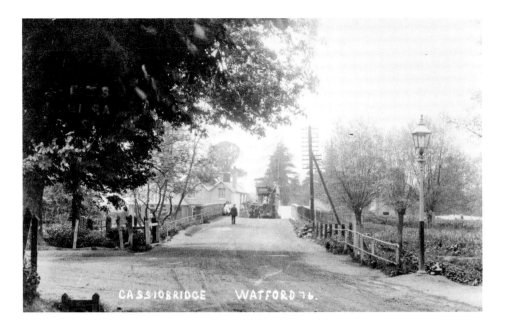

As the country was reeling from the devastating news of the fateful sinking of the RMS *Titanic*, this picture postcard of Cassio Bridge at the bottom of Rickmansworth Road looking towards Watford was mailed four days later, on 19 April 1912, to a Mrs B. Smith of Faversham. No mention of the disaster however, just the usual type of message relating to an impending visit on the Saturday. Adjacent to the bridge over the Grand Junction Canal (now the Grand Union) is Cassio Wharf, previously mentioned, where narrowboats would load their cargo ready to take up the waterway to their various destinations. Today, as can be seen in the 2012 picture below, the bridge has been considerably widened to accommodate the steady increase in the volume of traffic.

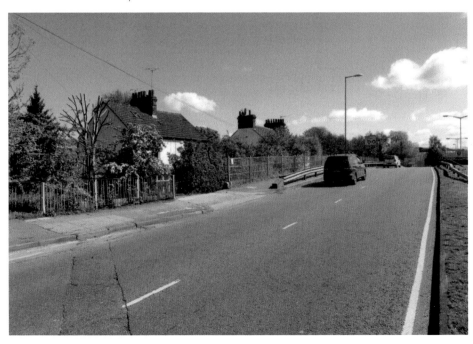

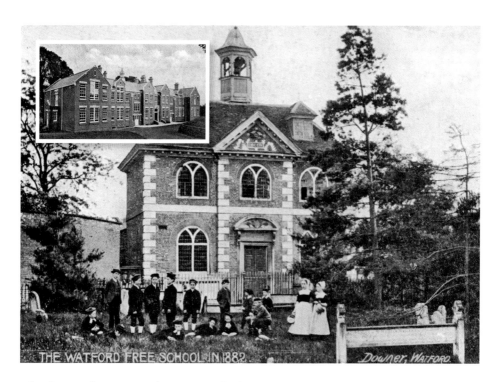

THE WATFORD FREE SCHOOL IN 1882. *Downer, Watford.*

Like the Boys' Grammar, the new Watford Grammar School for Girls, seen inset above shortly after it opened in September 1907, has its origins in the Free School that Dame Elizabeth Fuller founded in 1704. This elegant Queen Anne building is pictured above in 1882, shortly before its closure. From 1884, the girls were educated at the Endowed School in Derby Road in a separate building from the boys, where they remained until their move to the larger premises in The Crescent (now Lady's Close). Famous alumnae of the school include the former Spice Girl Geri Halliwell and *Eastenders'* actress Rita Simons.

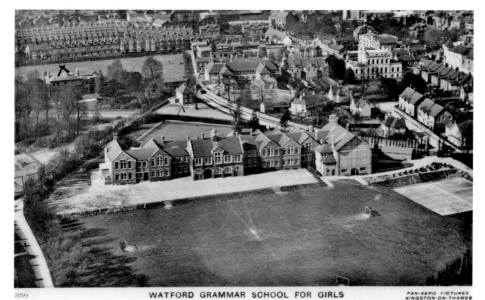

WATFORD GRAMMAR SCHOOL FOR GIRLS PAN-AERO PICTURES KINGSTON-ON-THAMES

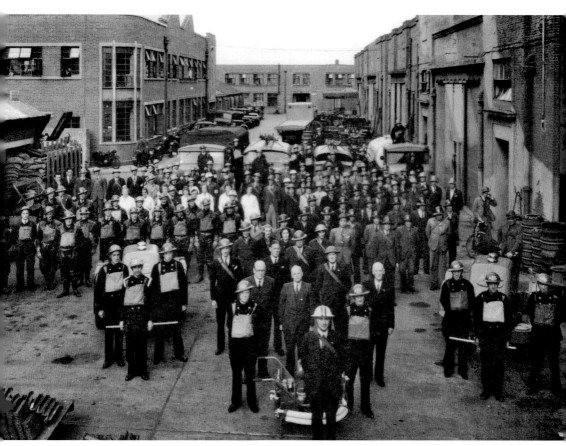

This photograph was taken at Scammell Lorries in Tolpits Lane, probably just after the outbreak of the Second World War. A lot of the men gathered are wearing helmets with the letters AFS. This indicates that they were part of the Auxiliary Fire Service, formed from volunteers to assist the regular fire brigades. It later became part of the new National Fire Service. Also pictured are members of the Civil Defence Corps. During hostilities, Scammell's contributed to the war effort by building large numbers of heavy recovery vehicles, Pioneer tank transporters and auto-coupling conversions, fire pumps, etc. Sadly, in February 1987 the news was announced that the factory was to close, with the final curtain coming down on one of Britain's greatest commercial institutions in July 1988. (Picture courtesy of Fred Richardson)

NIGHT
WAR WORKER
ASLEEP
QUIET
PLEASE
THANK YOU

G.B. & Co. (L.) Ltd.

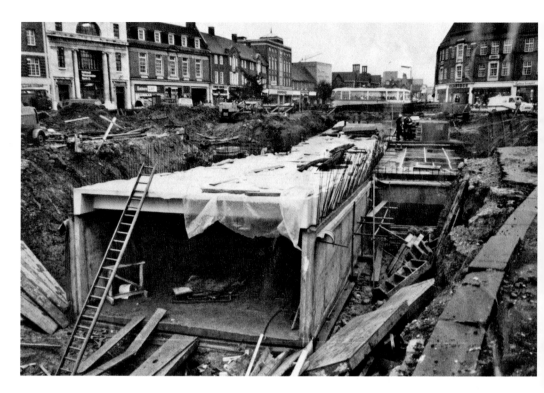

Taken from Hempstead Road and looking towards the High Street and the town centre, this picture shows the construction of the town hall underpass in 1972 and as it appears today. (Top picture courtesy of Watford Central Library)

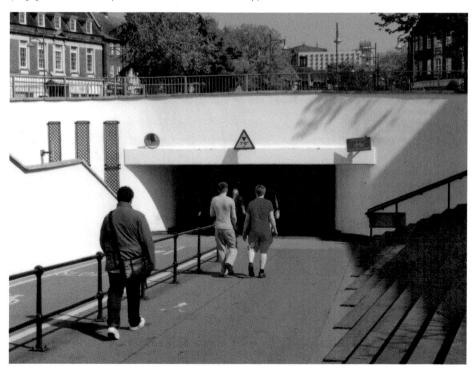

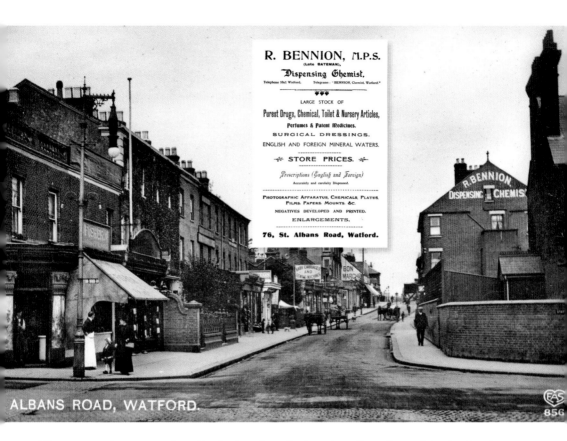

R. BENNION, M.P.S.
(Late BATEMAN),

Dispensing Chemist.

Telephone 10x1 Watford. Telegrams : "BENNION, Chemist, Watford."

♦♦♦

LARGE STOCK OF

Purest Drugs, Chemical, Toilet & Nursery Articles,

Perfumes & Patent Medicines.

SURGICAL DRESSINGS.

ENGLISH AND FOREIGN MINERAL WATERS.

❖ STORE PRICES. ❖

Prescriptions (English and Foreign)
Accurately and carefully Dispensed.

PHOTOGRAPHIC APPARATUS, CHEMICALS, PLATES,
FILMS, PAPERS, MOUNTS, &c.

NEGATIVES DEVELOPED AND PRINTED.

ENLARGEMENTS,

76, St. Albans Road, Watford.

ALBANS ROAD, WATFORD.

Like many major crossroads in Watford, such as the junction of Langley and Station Roads with St Albans Road, considerable change can be seen to have taken place between the early 1900s view and today's image. The most obvious is the implementation of a road widening scheme that resulted in the demolition of the buildings on the right-hand side. Part of the new dual carriageway was constructed from Station Road in late 1961 and the railway bridge was rebuilt in 1962/63. Although the shopfronts to the structures on the left have altered several times over the years some of the original architecture still remains from first floor to roof level.

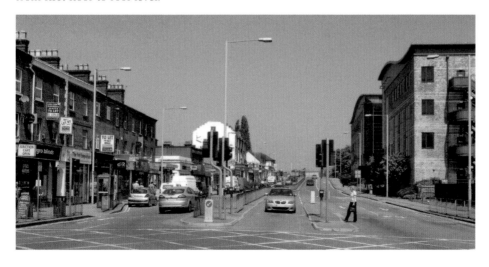

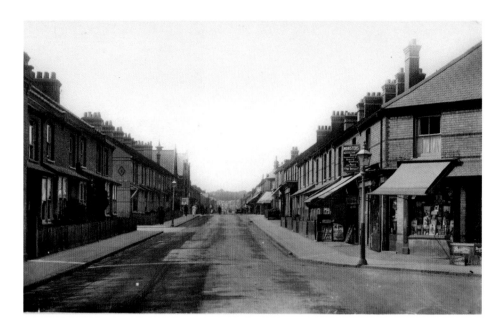

Very little change appears to have taken place in Leavesden Road when comparing the old postcard with the modern-day image. The small tobacconists and general store on the corner of Lowestoft Road seen above advertising Van Houten's and Rowntree's cocoa, Capstan cigarettes and Monsters Marvellous Minerals and claiming to be 'Unequalled in Quality, Quantity and Price' has gone, as well as the delightful old gas lamppost on the kerb side. Apart from the obvious cosmetic changes, the vista today of this quiet thoroughfare is much as it used to be in days gone by.

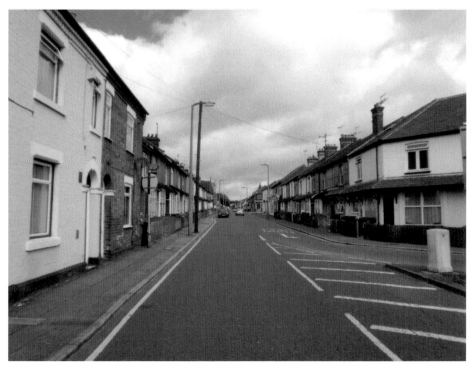

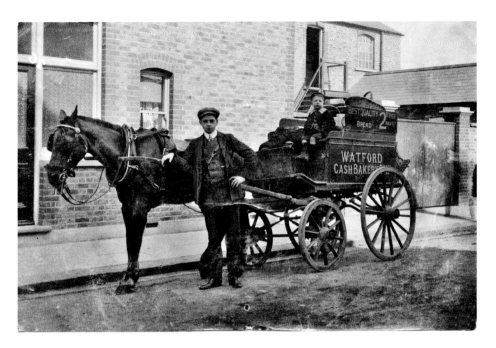

The horse and cart belonging to Watford Cash Bakers of 226 St Albans Road, is seen in this rare Edwardian card posted to a Mrs Huggett of Snodland, Kent, on 26 March 1907. The message from Allan reads: 'No time for writing this week, will write next. We are up to our eyes in work. What do you think of this Billie Boy on the van?' No doubt the youngster was eagerly looking forward to what was probably his first trip out on the delivery round.

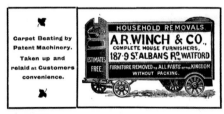

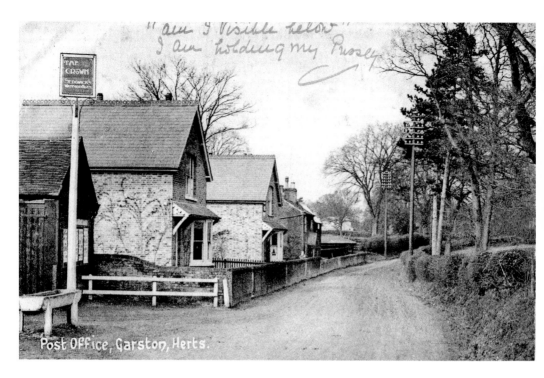

Post Office, Garston, Herts.

An interesting card, posted just after Easter in April 1908; it shows both the post office in St Albans Road, Garston, where it was franked, and in the centre of the picture, the sender holding her pet cat. To draw attention to this coincidence, the lady has written on the front of the card: 'Am I visible below. I am holding my pussey [sic].' With over 100 years separating the two images, this part of Garston is now occupied by a TGI Friday's and a Premier Inn.

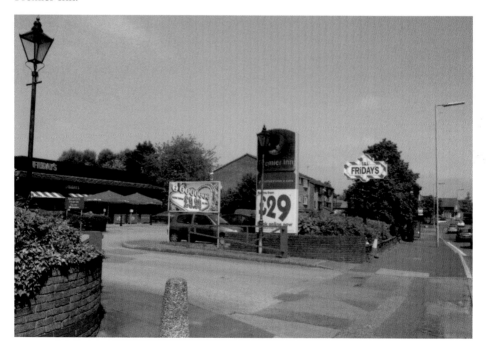

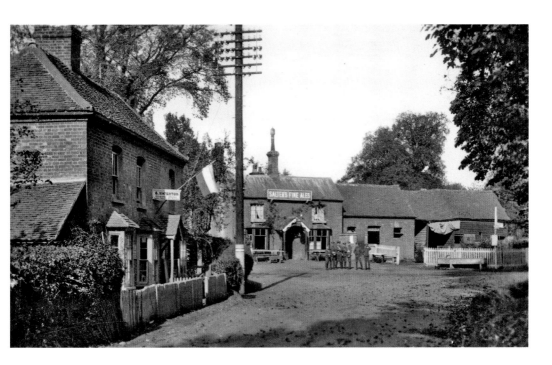

When compared to the earlier print above, photographed around 1914/15, today's view of this busy crossroads has changed out of all recognition. The group of soldiers are standing outside the Three Horseshoes public house in Garston, previously an old smithy and rebuilt about 1750, with the house on the left-hand side belonging to Sidney Waterton, a shopkeeper. The flag over the door of Mr Waterton's premises may well be the Dutch flag, but why it is on display is something of a mystery. The pub, which is the white building in the centre of the bottom photograph, is now a flourishing Harvester restaurant.

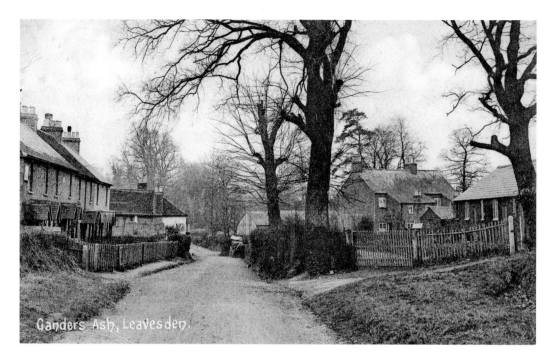

Ganders Ash in Leavesden, seen above in the early part of the twentieth century, was a narrow country lane in those days until 1952, when the area was extensively developed with social housing. Today, with some tenants having exercised their right to purchase their homes, Ganders Ash, on the border of Abbot's Langley and Watford, is now a quiet road of neat houses meandering from Leavesden High Road until it merges with The Brow, leading ultimately into Horseshoe Lane via Newhouse Crescent. The Hammer in Hand public house was originally a smithy kept by the Mallard family on the corner of Hunter's Lane and the High Road. It was demolished in 1960 but subsequently replaced in Ganders Ash in 1961.

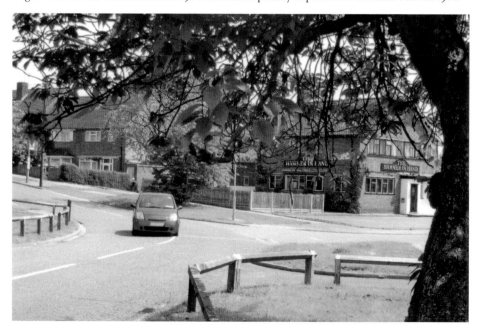

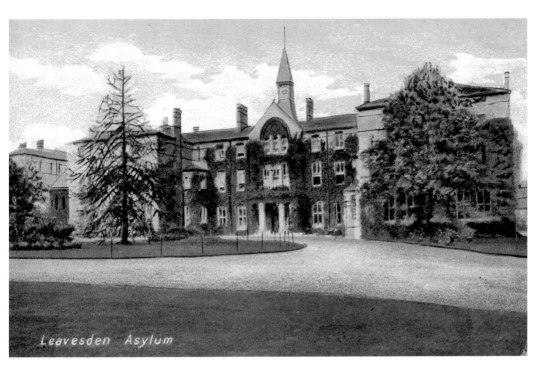

Leavesden Asylum

Prior to 1867, care for the mentally handicapped in London was virtually non-existent. They were either left to roam the streets, were admitted to the workhouse or at worst the lunatic asylum. In that year of 1867, following the establishment of the Metropolitan Asylums Board, a site of 76 acres was purchased at Leavesden near Watford with the new building opening on 9 October 1870. During the following years, the emphasis changed from detention and segregation to prevention and treatment. This led to the gradual resettlement and integration of patients into the community resulting in the termination of institutions such as Leavesden, which eventually closed in October 1995. The building has now been converted into private residential accommodation.

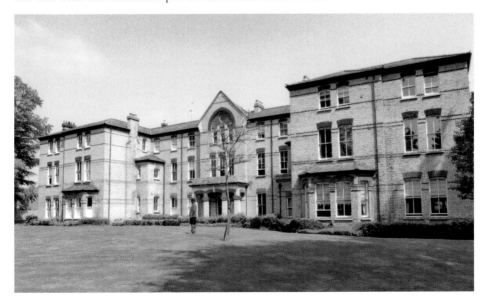

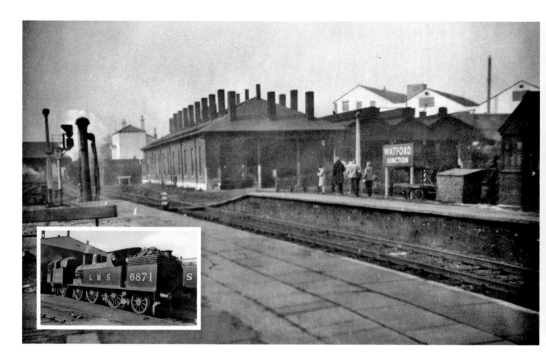

Taken on Saturday 2 March 1963, the photograph above shows Watford Junction Engine Shed, where locomotives were serviced and maintained, nearing the end of its useful working life. The shed was constructed in the 1870s, with an enlargement taking place in the 1890s, but with the coming of electrification it was closed in 1965 and was subsequently demolished. The white building on the left was the Stationmaster's house, while the large white structure just visible in the background on the right was the Fishburn Printing Ink factory, situated where the old Cassiobury Saw Mills used to be. With Fishburn's move from Watford in the late 1980s, a Homebase store now occupies the site. The bottom picture shows the same view today.

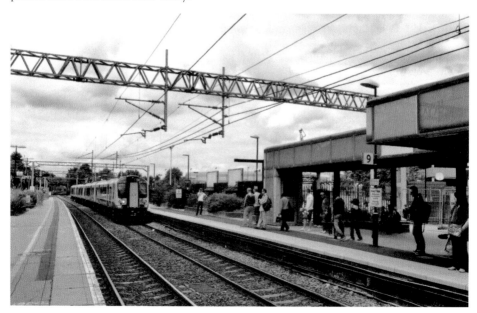

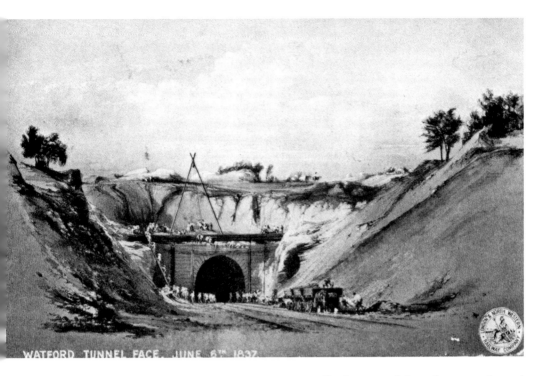

Watford Tunnel under construction, 6 June 1837. Originally, the route of the railway was planned to pass through the estates of the Earls of Essex and Clarendon, but due to their opposition a new route that necessitated a cutting north of Watford Junction was put in place. The tunnel was 1 mile 170 yards long, 25 feet high and 24 feet wide and accommodated a two-track line. Ten workmen lost their lives during the excavation.

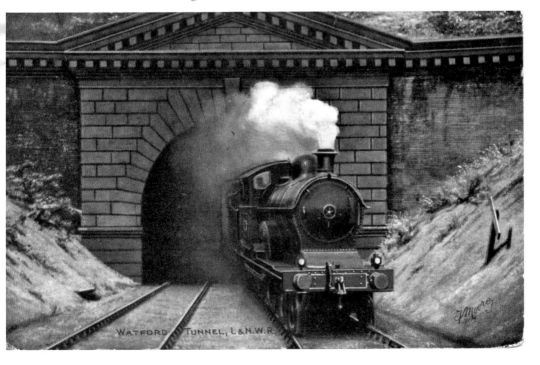

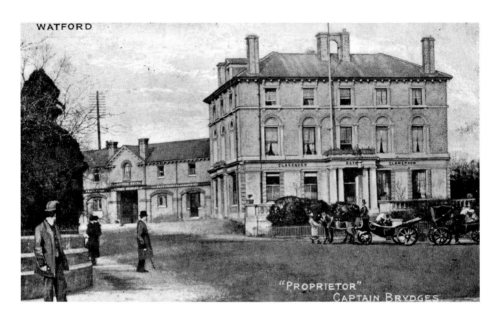

"PROPRIETOR"
CAPTAIN BRYDGES.

Above: Built in 1860, the Clarendon Hotel is seen above in the Edwardian era when the proprietor was Captain H. Brydges. Over the years there have been several name changes including The Pennant, the Flag & Firkin and now enjoying immense popularity as The Flag, 'the most established music venue in Watford'. On 12 September 1975 the building was given Grade II listed status.

Below: Photographed outside Watford Junction Station in around 1935, with the Clarendon Hotel on the left of the picture, this green double-decker bus, Fleet No. ST 140, was at the time on Route 336 to Berkhamsted via Croxley Green, Rickmansworth, Chenies and Chesham. The bus remained in Watford until 1938 but was based in Surrey during the Second World War, where it covered routes to Addlestone and Merton. In October 1952 it was withdrawn from service and over the next two years underwent several sales transactions before being finally withdrawn altogether and cut down and adapted for use as a lorry.

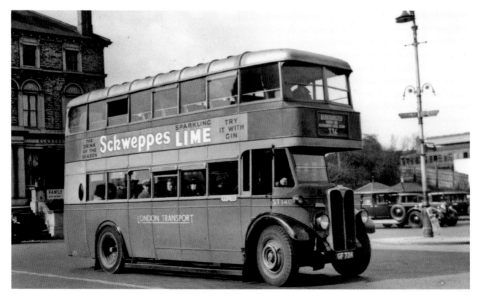

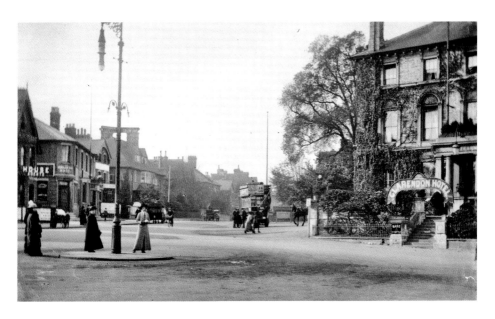

These charming postcards, taken just before the outbreak of the First World War, capture a moment in time. We are shown two views of Station Road, with the Clarendon Hotel and Watford Junction in the background. In the centre of the above image can be seen a lovely old omnibus with an outside staircase leading to an open top deck – fine in the summer but not so good in the depths of winter. Station Road at that time was adequately provided with hotel accommodation: the Malden, the Verulam (seen on the left in the top picture sandwiched between two estate agents), and the Clarendon. In the picture below, a number of men are gathered round the open bonnet of an omnibus, probably deliberating over a minor mechanical fault, while the ladies chatting at the rear are likely debating whether there is sufficient time to take tea in the Temperance Refreshment Room which can just be seen adjacent to the station.

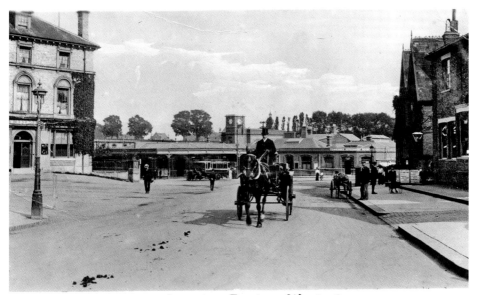

40. Junetion Station, Watford.

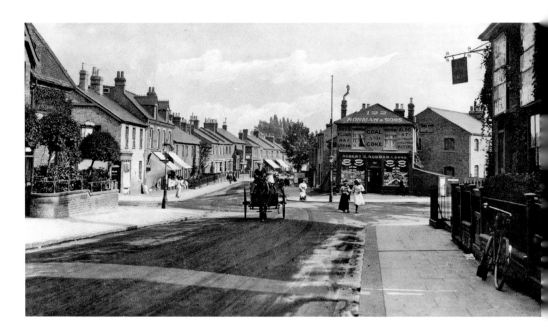

Another early 1900s street scene is captured here by the photographer in Woodford Road, just up from Watford Junction, showing the crossroads with Asylum Road (now Orphanage Road) on the left, Queen's Road straight ahead and St John's Road on the right. The small store in the background is Robert G. Norman & Sons, purveyors of coal and coke, corn, flour, hay and straw. Now rebuilt, the premises are occupied by Custom Hose & Fittings, high-class specialist hose suppliers. The public house on the right-hand side of the image is the Estcourt Arms and on the opposite corner of Asylum Road is the Wellington Arms. Both pubs were established in 1869 and are still flourishing today.

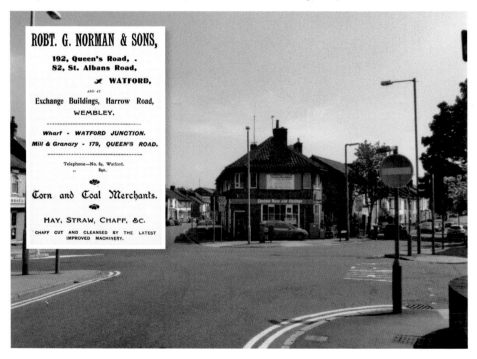

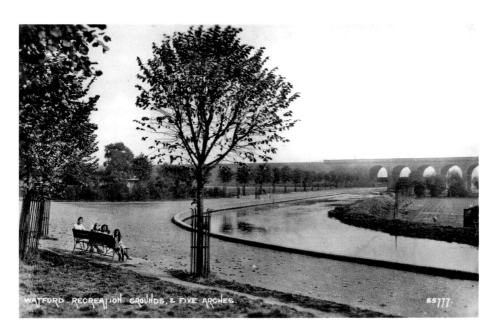

It was here in the shadow of the Five Arches railway viaduct over the River Colne (above) that an open-air public bathing place was cordoned off to form a large, square-shaped lido. Around this area were a number of wooden changing cubicles and a spectators' viewing gallery. Certain hours were set aside for ladies and the season extended from about the middle of April to the middle of October. The Watford Amateur Swimming Club did much to promote the success of the Bathing Place and the encouragement of swimming, holding its annual gala there, which was always well attended. It was so popular that on one hot day in June 1893, 560 people were recorded as having used the facilities. However, conditions were most unhygienic when compared to modern standards. Following the discovery of sewage in 1936, a decision was made by Watford Council for the Bathing Place to be closed – no doubt an unpopular ruling for many, despite the new up-to-the-minute indoor swimming pool that had opened in Hempstead Road three years earlier.

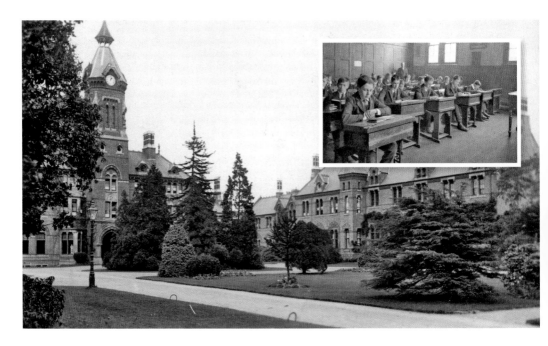

Originally based in Clapton, the London Orphan Asylum was founded in 1813 by Andrew Reed for 'the education of respectable fatherless children of either sex'. Following a serious outbreak of typhus in London, the asylum moved to a beautiful site in Watford in 1871, where there was accommodation for 600 orphans. In 1915 it was renamed the London Orphan School and again as Reed's School in 1939. The top picture of the school buildings is from a lovely card that was posted on 1 April 1919 to a Mr J. Payne of Rickmansworth wishing him 'Many Happy Returns of the Day' from his mum, while the whole school can be seen gathered for a group photograph (below), most of the youngsters looking as though they would rather be somewhere else. The inset image is a carefully posed picture of the senior boys' classroom. During the 1980s, following the granting of Grade II listed status in 1983, the buildings were converted into residential accommodation.

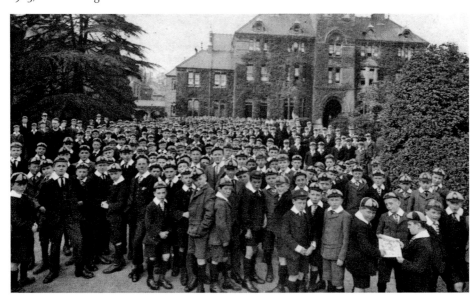

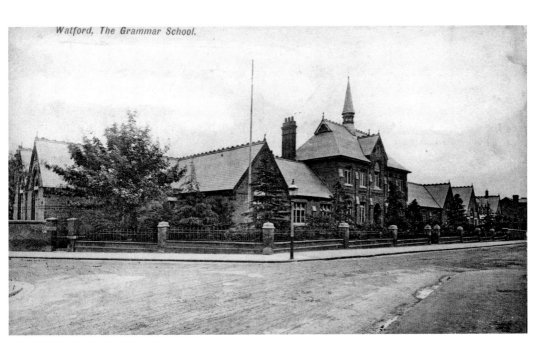

Watford, The Grammar School.

Sidney Edwards appears to have been a very bright nine-year-old, so his report for the half-year ending 21 December 1900 tells us. As a pupil at the Watford Endowed School in Derby Road, he is described as an 'industrious and careful boy in his work and has made good progress. General conduct: Excellent.' The school buildings for both the boys and girls were opened by the Earl of Clarendon in 1884, with an initial intake of sixty-nine boys and forty-six girls. However, by the turn of the nineteenth century it was apparent that both schools were far too small to cope with the increasing demand for places and steps were taken to find alternative sites. By 1907 new premises had been built in The Crescent (now Lady's Close) for the girls, with the boys moving into a modern and spacious development in Shepherd's Road five years later, Watford's new grammar schools. The old Endowed School buildings in Derby Road are now the Central Primary School and Nursery.

WATFORD ENDOWED SCHOOL.

LOWER SCHOOL.

Report for the Half-Year ending _Dec. 21st_ 1900

Name _Edwards Sidney C.D._ Form _i (L)_

SUBJECTS.	Full Marks.	Marks obtained.	Remarks.
Religious Knowledge	80	60	G.
Reading and Repetition	100	70	v.g.
Writing	100	85	v.g.
Dictation and Spelling	100	90	G.
Arithmetic	120	110	Ex.
English Grammar	—	—	
English History	60	48	G.
Geography	60	45	v.g.
Drawing	100	45	v.g.
French	—	—	

N.B.—Half-Marks are given for Class Work and half for Examination.

Conduct	60	60	**Place in Form**	4 7/11

Attendance—Absent _14_ times. No. of Pupils being _10_.

Punctuality—Late _—_ times. Average Age _9_ years _3_ months.

General Conduct and Progress _He is an industrious and careful boy in his work and has made good progress. General Conduct: Excellent._

The next term will begin
on _Tues. Jan. 15th 1901._ _C.R. Johnson,_ Master of Lower School.
when every boy must be in attendance. _W. R. Carter,_ Head Master.

67

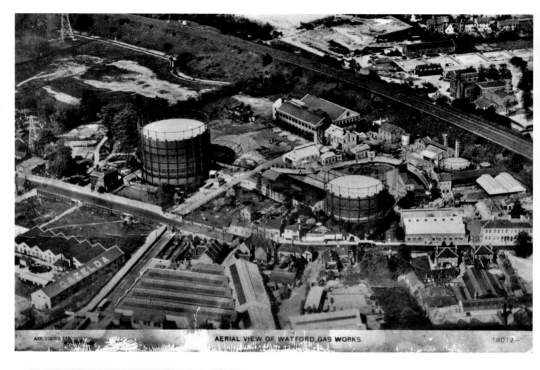

AERIAL VIEW OF WATFORD GAS WORKS 18012

The Watford Gas and Coke Company was formed in 1834 to supply the needs of both Watford and Bushey. The introduction of this new commodity was not initially very popular, but as lamp standards were erected to light the streets the general public gradually started to realise that they too could illuminate their homes with gas. An interesting energy saving point at the time was that street lamps should not be lit when there was a full moon due. In the early days, the consumption of gas was not metered, the rates being levied according to the hours the lights were left on. Delivery of coal was, until the advent of the railway, by narrowboat to Cassio Bridge wharf and then by road to the gas company's works in Lower High Street. The above unused postcard shows an aerial view of the bottom of the town with the gas holders in the centre. Gazelda Ltd, leather goods manufacturers, can be clearly seen in the left-hand corner of the picture, probably taken in the early 1930s.

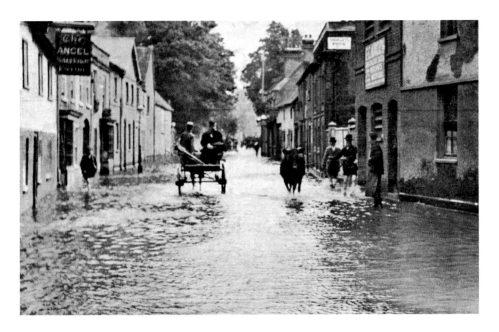

Local photographer William Coles of Queen's Road captured this watery thoroughfare at the bottom of Lower High Street, above, near the Angel public house following the flood of Tuesday 16 June 1903. This being market day, the two drovers can be seen leading a bull to the livestock sales in the centre of town. The Angel, which was built around 1750, had only a short time left before it was demolished later in 1903. The approximate site is now occupied by George Ausden, scrap iron and metal merchant. The same scenario was repeated on 29 December 1914, with the omnibus and car looking well and truly waterlogged – an all too frequent occurrence in that part of the High Street. The card was posted on 14 August 1915.

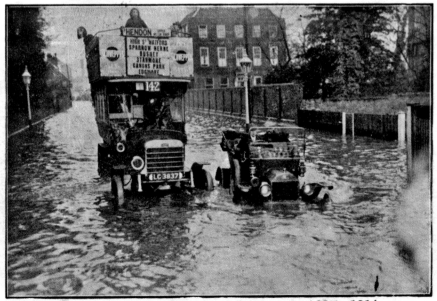

The flood in Lower High Street, Watford, Dec. 29th, 1914.

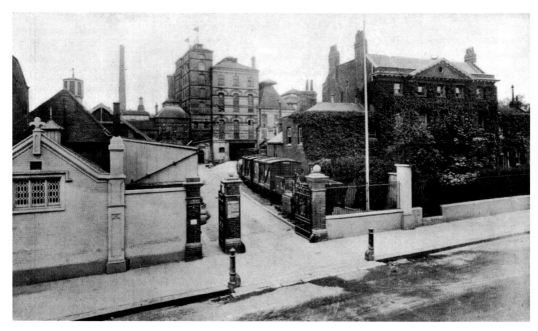

BENSKIN'S WATFORD

SPECIALITIES :—

LIGHT SPARKLING ALE	-	**2/6**
INDIA PALE ALE	-	**3/6**
IMPERIAL STOUT	-	**4/-**

per dozen pint bottles.

"BONNIE SNOOD"		per bottle.
SCOTCH WHISKY	-	**4/-**
HOME-BREWED		per gallon.
GINGER BEER	-	**10d.**

Full price list on application.

BREWERY, LIMITED.

Following the death of John Dyson in 1867, the Cannon Brewery in Lower High Street was auctioned off and purchased by retired London hotelier Joseph Benskin and his partner William Edmund Bradley for £34,000. When Bradley left the partnership in 1870, Benskin continued with the business until his death seven years later. Over the years, Benskins gradually acquired all of the other Watford Breweries: Healey's in 1898, Sedgwick's in 1923 and Wells' in 1951. With a successful takeover bid from Ind Coope in 1957, together with further subsequent mergers, the company then became Allied Breweries, continuing in Watford until production ceased in the early 1970s. Although the site was gradually demolished during the 1970s, the fine Georgian mansion that John Dyson's father, also John, had purchased in 1812 remains today as Watford's prestigious museum.

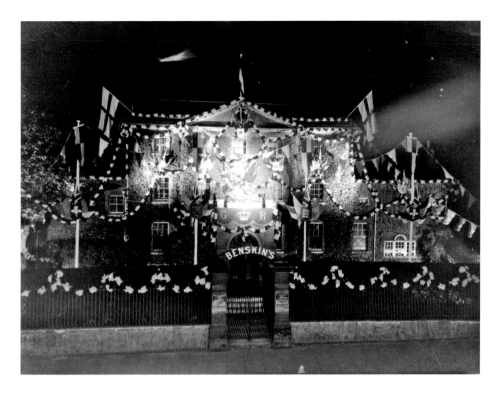

Above: A night-time view of the Brewery Offices in Lower High Street decorated and illuminated to celebrate the Silver Jubilee of HM King George V on 6 May 1935.

Below: A single horse van, probably dating from the turn of the nineteenth century, which won First Prize at the Watford Carnival in 1936.

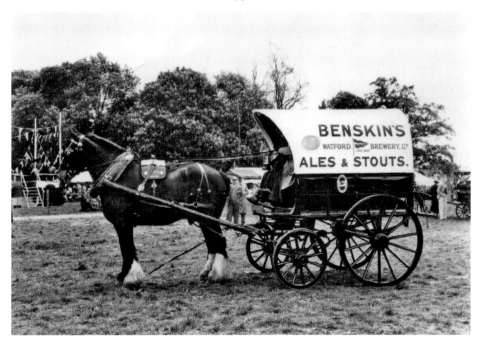

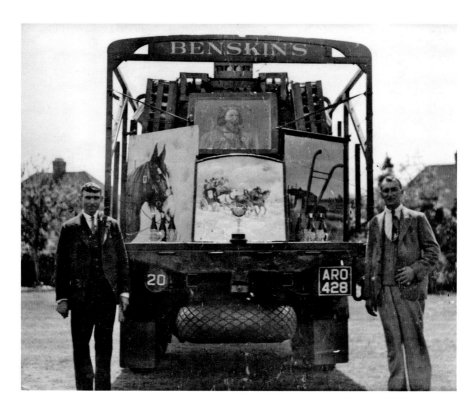

This picture captured in 1948 shows a Benskins lorry loaded with a variety of pub signs, probably being taken to the workshops of E. Miller & Sons, sign writers in King Street for cleaning and touching up, as can be seen below, before being returned to the public house from whence they came.

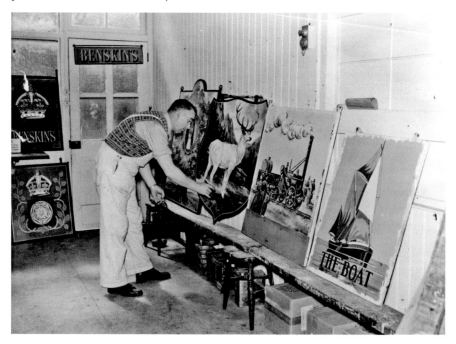

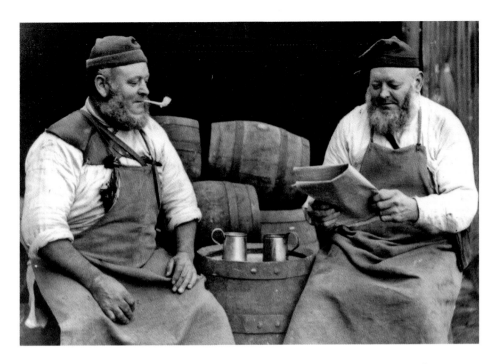

Above: Pictured are the Rixon brothers, two draymen who worked for Sedgwicks Brewery before it was taken over by Benskins in 1923, taking a well-earned break between deliveries.

Below: Benskins Brewery depicted in 1949.

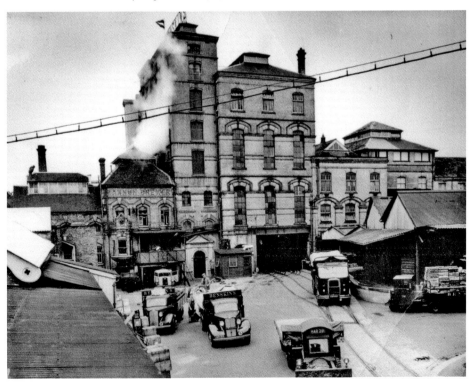

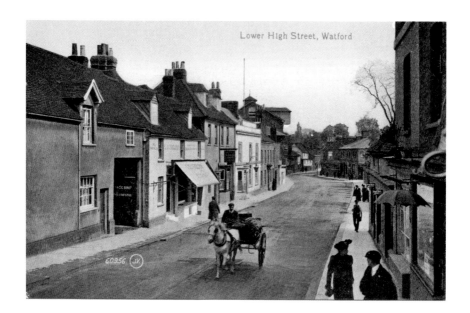

Although this postcard was never sent through the mail and no address or names were given, there is a short message on the back which reads: 'This part of our High Street as you can see is very old and to my way of thinking not at all beautiful.' This may well have been the case, but at least the view had plenty of character. To the extreme left of the picture, just out of camera shot, is Sedgwick's Brewery, which in 1876 obtained the first steam fire engine to be used in Watford. It attended most of the fires in the town at that time. Next door to the premises of Stagg Brothers at No. 229 and the butcher's shop of George Dumbelton is the Brewers Arms at No. 233 which was demolished in 1911. Another public house, the Leather Sellers Arms, is at No. 235; a footpath between the buildings separates them. The licensee in the early 1930s was Thomas George Apps. The pub was demolished in 1960. An interesting point is that No. 237 (the white building in the centre) was an antiques shop owned at one stage by an uncle of Jimmy Perry of *Dad's Army* and the Palace Theatre fame. Today, following widespread redevelopment, Lower High Street has changed out of all recognition. Watford's modern £5 million state-of-the-art fire station can be seen below.

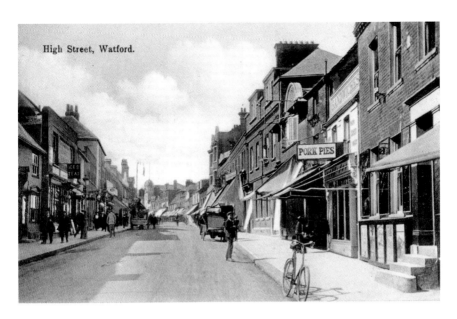

High Street, Watford.

Photographed in around 1912, at a point just above where the ring road bisects the High Street today, the image clearly shows Joseph Nevitt's ham and beef shop on the right with his prominent sign advertising 'Pork Pies'. A display board on the frontage also proclaims that sandwiches are available too. The building just visible on the extreme left was the premises of John Mayfield, a confectioner and tobacconist which today is a Watford Peace Hospice charity shop. Either side of Crown Passage on the left were two public houses, the One Crown at No. 156 dating in part back to the sixteenth century and thriving as a popular venue to this day. The Three Crowns at No. 160 was one of Watford's oldest pubs originating from around 1600 as the Bull, later becoming the Crown. It underwent a further name change in 1750 when it became The Three Crowns. It is now the men's hairdressing salon Headhunters. Both buildings were granted Grade II listed status on 7 January 1983.

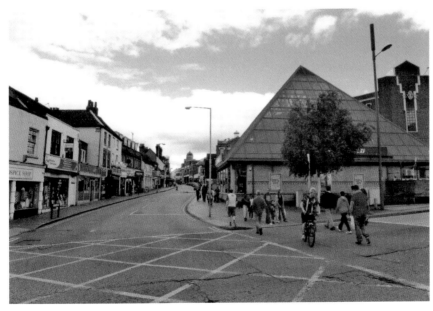

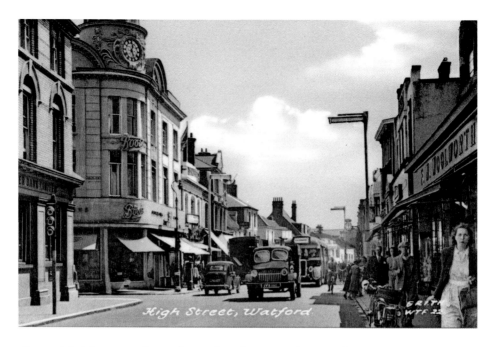

Above: A bright sunny day is depicted in this unused postcard showing the junction of Queen's Road with the High Street in the early 1950s. King Street is just down on the right-hand side past Woolworth's, where Mrs L. Packer was 'Mine Host' of the King's Arms public house on the corner of what was once the gate lodge of the carriageway leading to Watford Place. A McDonald's fast food outlet now occupies the site of the old inn. On the opposite side of the High Street, where Boots the Chemist once traded, is now the imposing entrance to the Harlequin Shopping Centre, which opened its doors in 1992. Boots is now one of the stores within the centre. The absence of yellow lines on the road was certainly an invitation to motorists that they could park where and when they liked, although the volume of traffic was already starting to increase the congestion in the town.

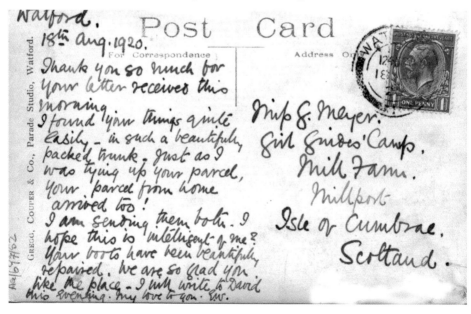

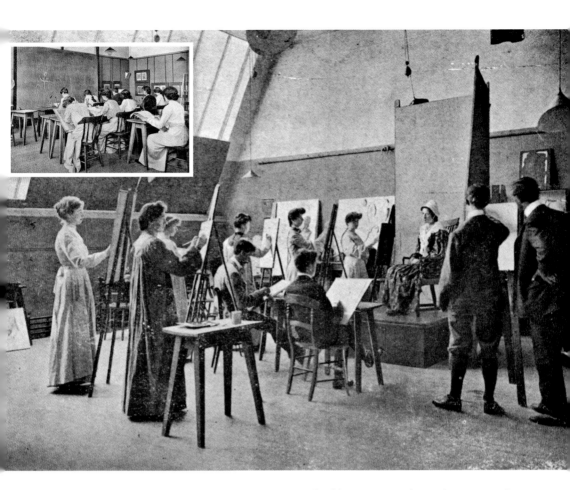

Above: The Watford Public Library was an imposing building in Queen's Road constructed on a site donated by Mr Thomas Clutterbuck. Following the adoption of The Libraries Act in 1871 subscriptions were obtained for the building, which was completed in 1874 and opened by Mr T. F. Halsey. The library also embraced a School of Art which included The Life & Painting Room (seen above) and The Design Room (inset). Various evening classes were added to the courses from time to time until 1889, when the adoption of the Technical Instruction Acts enabled the Committee to establish a more extended school on the lines of a technical institution. This lead to a considerable increase in the number of students and the building was enlarged several times between 1888 and 1908. Its thirty rooms were devoted to the Public Library proper, the teaching of art, science, music, and commercial and literary subjects. There were, in the whole of the technical section of the institution, between 900 and 1,000 students. It was estimated that about 60,000 books were issued from the lending and reference sections in a year, with the open access system being adopted with a great deal of success. When the Public Library moved to new premises in Hempstead Road in 1928, the Library and School of Science & Art was used as a Technical School.

Opposite page, bottom: Written and posted on 18 August 1920 to a Miss G. Meyer at a Girl Guides' Camp in Scotland, E. W. wrote: 'Thank you so much for your letter received this morning. I found your things quite easily – in such a beautifully packed trunk. Just as I was tying up your parcel, your parcel from home arrived too! I am sending them both. I hope this is intelligent of me? Your boots have been beautifully repaired. We are so glad you like the place. I will write to David this evening. My love to you, E.W.'

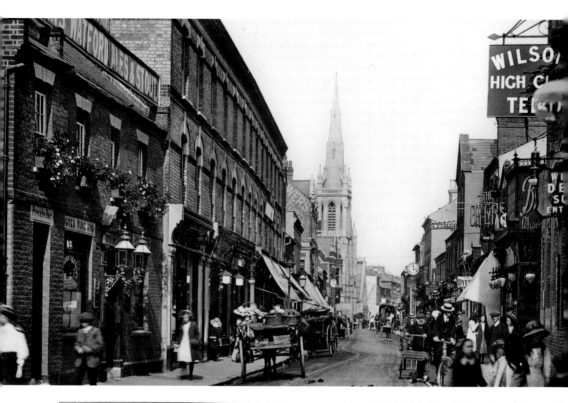

WILLIAM COLES,

For Pleasing Portraits of Children.

A Good Portrait makes a most acceptable Xmas Present.

PHOTOGRAPHER,

For Photographs in Fancy Dress.

Portraiture by Electric Light.

16, QUEEN'S RD., WATFORD.

ELLIOTT'S

Pianoforte & Music Warehouses.

The largest and most varied Stock of Music and Musical Instruments in the County.

Agent for the Orchestrelle Co's. Celebrated Instruments.

PIANOS
by
Bechstein,
Brinsmead,
Broadwood,
Chappell,
Challen,
Collard,
Cramer,
Lipp,
Ibach,
Steck,
&c.

ORGANS
by
Bell,
Karn,
Mason and
Hamlin,
and
Hillier
FROM
5 Gns.

PIANOS
FROM
14 Gns.

Pianola - Pianos from 70 Guineas.

Lowest possible Cash prices or on the Hire Purchase System.

Lists and detailed description on application.

Tunings and Repairs by Skilled Workmen.
Estimates free.

ELLIOTT'S, Queen's Road, WATFORD.

ALSO AT HARROW AND ST. ALBANS.

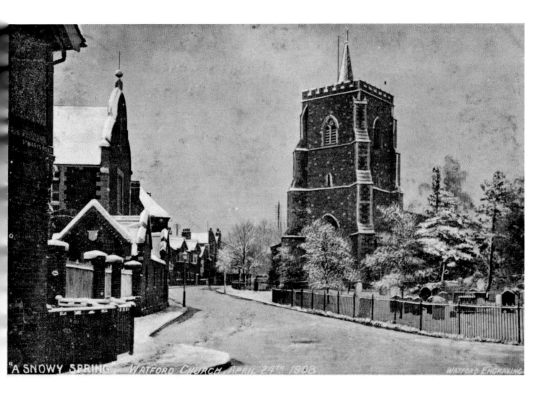

Above: This lovely snow scene of the beautiful church of St Mary was photographed on Friday 24 April 1908 and is depicted here by the Watford Engraving Company. The postcard, franked at 7 p.m. on 30 September 1908, was sent from E. B. in Hatch End to a Mrs Barker of Mill End, Rickmansworth, confirming the train times for an impending visit. The church was built around 1230 although the imposing bell tower was added during the fifteenth century. One of the more interesting graves in the churchyard was that of George Edward Doney, a black slave and a native of Virginia who for forty-four years was a faithful servant to George Capel-Coningsby, the 5th Earl of Essex. George Doney was christened on 1 August 1774 when he was about sixteen years of age and was buried on 8 September 1809. The road in front of St Mary's, appropriately named Church Street, was once home to the workhouse and the engine house for the parish manual fire pump.

Opposite page: Posted in 1915, this charming postcard shows Queen's Road, one of Watford's busy shopping thoroughfares, at 12.15 p.m. on a warm summer's day. The Wesleyan church in the background was consecrated on Wednesday 16 January 1889. It was built on the corner of Derby Road at a cost of £8,800 and could seat 1,100 worshippers. Seen on the left of the picture is the Queen's Arms Inn, a Sedgwick's house until the brewery was taken over by Benskin's in 1923. It was built in 1862 and demolished in 1968. The pub was originally owned by one John Kilby, former landlord of the Eight Bells. Other established businesses in Queen's Road included the premises of William Coles, the well known local photographer, and Elliott's, the pianoforte and music warehouse where a piano could be purchased from 14 guineas. Their advertisements can be seen here.

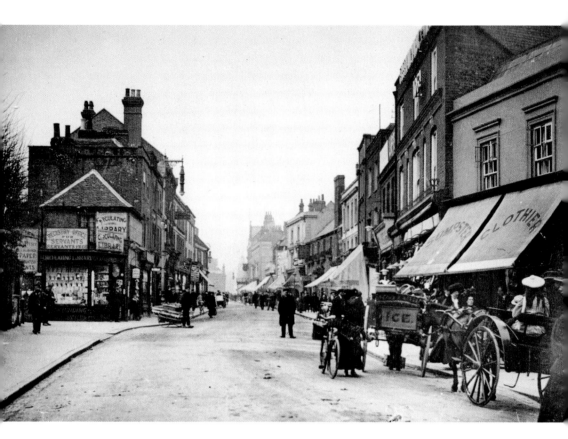

With the presence of the photographer attracting a certain amount of interest from some of the passers-by, this early snapshot has captured some interesting details of the times. The advertisements on the side of the building to the left indicate that the premises there were used for a Registry Office for servants, probably an early type of recruitment agency, and a Circulating Library. The library which served the general reading interests of ordinary people could, for a small fee, allow readers to access a wide range of popular reading material, although this facility started to decline in the early twentieth century with public libraries offering their services for free. To the right at No. 105 can be seen the shop of E. Sumpster, clothier, with a pony and trap parked outside, a far cry from the busy High Street that it is now.

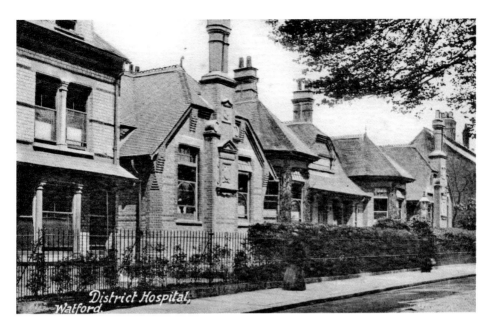

Built in 1885, the Cottage Hospital in Vicarage Road later came to be called the District Hospital. It originally had nine beds, but in 1897, to mark the Diamond Jubilee of Queen Victoria, a new six-bed ward and an operating theatre were added. In 1903, new dining rooms and staff accommodation together with two additional six-bed wards were built to provide a total capacity of twenty-seven much needed beds. The inscription on a tablet at the front of the hospital states: 'This stone was laid by the Countess of Clarendon Nov. 4th. 1885.' Today this old building is used for office accommodation.

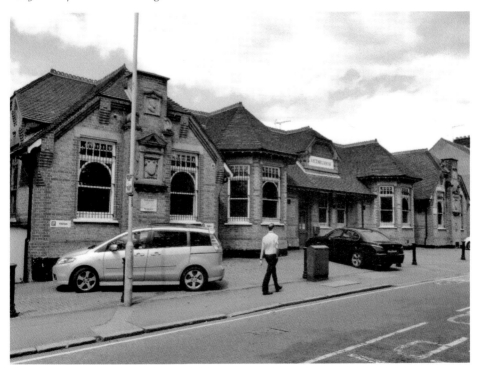

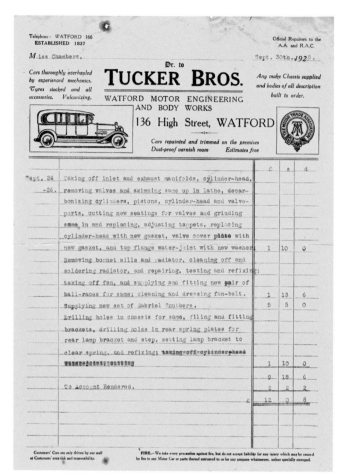

left: It is amazing to see that the invoice above submitted to a Miss Chambers from Tucker Brothers, Motor Engineers in the High Street for work carried out on 30 September 1925, came to the princely sum of just £12 0s 8d, a figure that would be hundreds of pounds today.

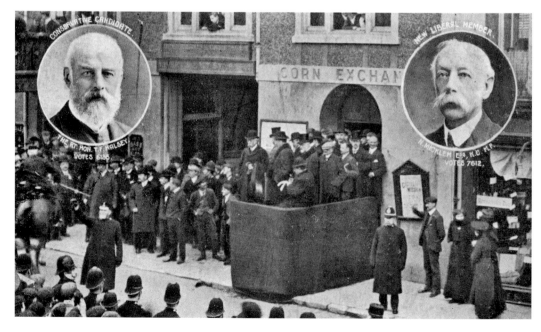

This page and opposite, bottom:
A large expectant crowd had
gathered outside the Corn Exchange
next to the Essex Arms Hotel in the
High Street on 24 January 1906, a
wintry day, to hear the declaration
of the poll between the Liberal
candidate, Nathaniel Micklem, and
the Conservative, The Rt Hon.
T. F. Halsey. The result was a win
for the Liberal who defeated the
Conservative by a majority of 1,476.
The message on this postcard sent
on 22 January refers to a large
Liberal meeting that had been held
nine days prior to the poll in the old
Clarendon Hall on the 15 January:
'Great L. (Liberal) meeting tonight
– procession from L. Club headed
by brass band & all sorts. I hear
they are going to appeal against
C. (Conservative) member at
St Albans on ground of unfair
play.' Over 100 years later, with the
buildings in the bottom picture long
since gone, part of the area now
forms the entrance to Charter Place
Shopping Centre.

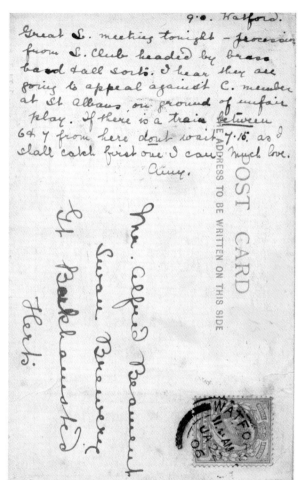

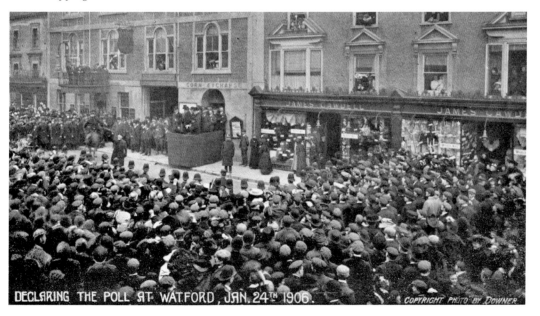

DECLARING THE POLL AT WATFORD, JAN. 24TH 1906. COPYRIGHT PHOTO BY DOWNER

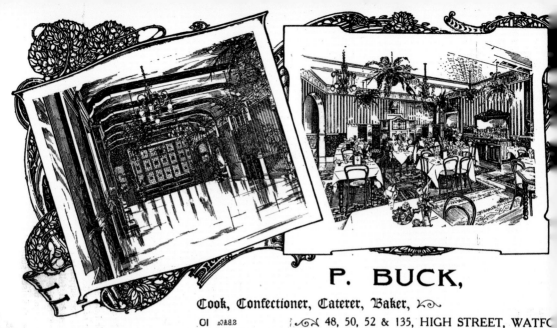

P. BUCK,

Cook, Confectioner, Caterer, Baker,

OI 0282 48, 50, 52 & 135, HIGH STREET, WATFO

Temporary Ball Rooms, Marquees, Bazaar Fittings, Plate, Cutlery, &c., on Hire. Exceptional Suite of Rooms suitabl
Private Dances, Banquets, Wedding Receptions, Concerts, &c,

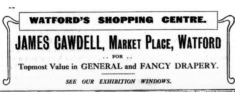
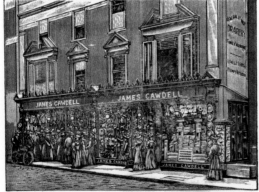
Advertisements for P. Buck: cook confectioner, caterer and baker; and James Cawdell's draper's.

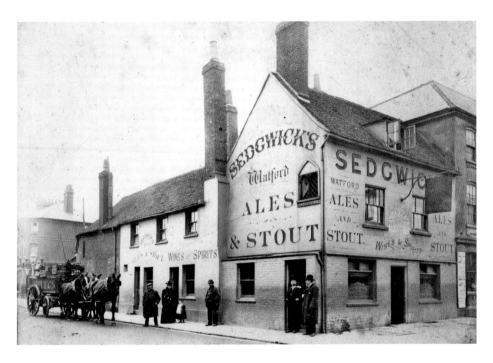

The Compasses public house situated on the corner of the High Street and Market Street, pictured above around 1890, was built about 1725. In 1888/89, following a partial demolition of the premises next door when Market Street was opened up, a fifteenth-century window was discovered which is still preserved to this day. It is seen on the bottom left-hand side of the building in the photograph below. The legend on the accompanying plaque states: 'The above window was removed from the old Compasses Inn demolished in 1928. It is believed to have been one of the windows of the Rest House which stood on this site in the fifteenth century to serve those attending Watford Market. It is noteworthy that Watford Market received its Charter in the reign of Henry I.' Moss, the menswear retailer, now occupies the premises.

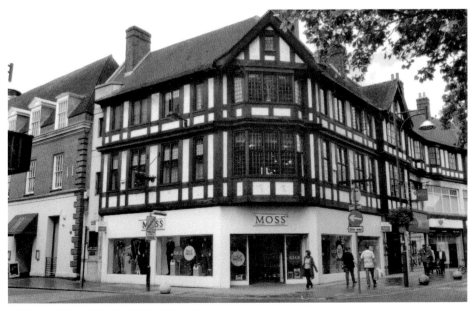

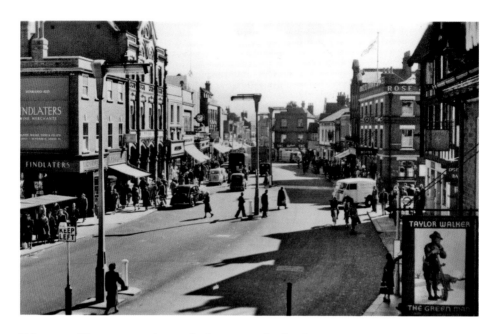

Taken over fifty years ago during the late 1950s, this lovely picture of the High Street above shows it to be relatively traffic-free at a time when there were no restrictions on where to drive or park, with buses-only access, pedestrianisation and yellow lines still a long way off. The view takes in the old market place where every Tuesday, a bustling livestock market was once held, a noisy and smelly place at the best of times, although a general merchandise market offered its wares for sale on a Saturday as depicted below in a similar view photographed during the early 1900s. The Essex Arms Hotel, the Rose & Crown and the Green Man public house in the two images have all since been demolished.

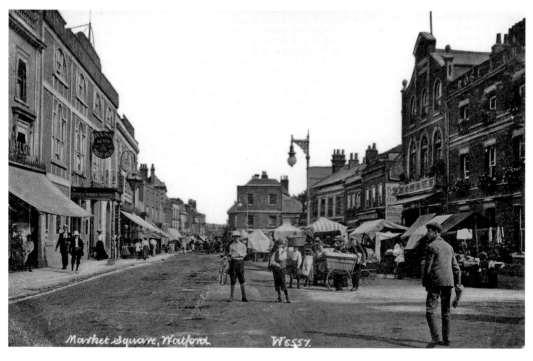

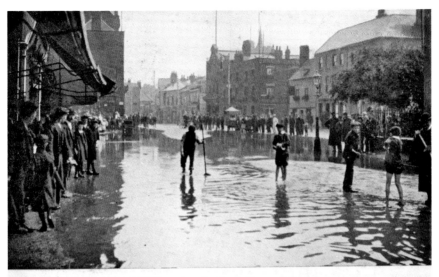

Watford Market Place after the Great Storm, July 27th, 1906. *Downer*

Yet another deluge to flood the streets of Watford, the Great Storm as the photographer described this picture, took place on Friday 27 July 1906. Taken from the relatively dry part of the pavement outside Charles Barton's bakery in the Market Place, the image shows one solitary person, watched by a large group of onlookers, optimistically surveying the water level with a broom, although what he hoped to achieve is somewhat questionable. The large building in the middle background is the Rose & Crown, since demolished, on the corner of Market Street. Rogers & Gowett, ironmongers (see advert and invoice below), can just be seen on the left of the picture, on the corner of Meeting Alley.

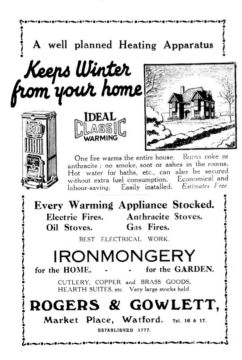

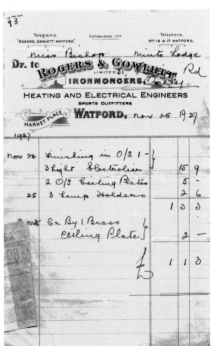

For Satisfaction

No relation to the author!

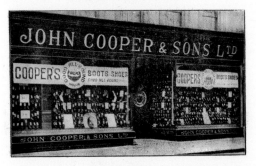

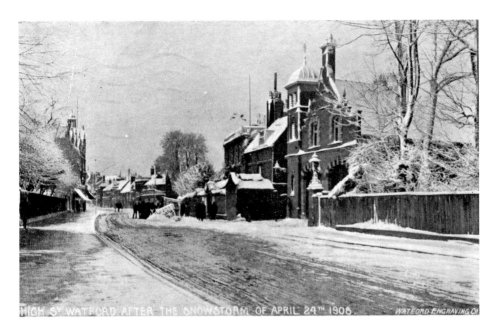

HIGH ST WATFORD AFTER THE SNOWSTORM OF APRIL 24TH 1908. WATFORD ENGRAVING Cº

Another wintry scene in the High Street at the north end of the town after the snowstorm on Friday 24 April 1908. The new fire station that was opened in the summer of 1900 can be seen in the foreground next to the Urban District Council Offices where Gade House is now situated. Watford's largest fire at that time was the conflagration that broke out in the early evening of Saturday 7 February 1903 at Dr Tibbles Vi-Cocoa Factory in Callowland attracting about 20,000 people from Watford and the surrounding area. The Watford brigade together with brigades from Sedgwick's Brewery, Bushey, Rickmansworth and Croxley were soon on the scene and despite sustaining extensive damage, much of the factory including the engine rooms, boiler sheds, carpenters' shop and a substantial amount of coal and timber were saved despite the low pressure of water available.

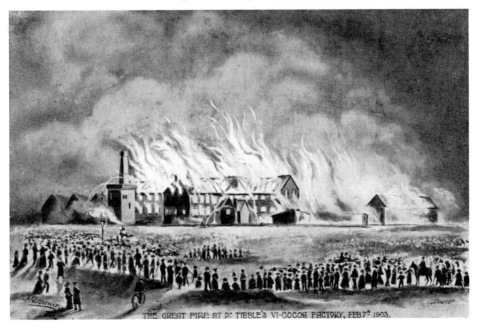

THE GREAT FIRE AT Dr TIBBLE'S VI-COCOA FACTORY, FEB 7º 1903.

This picture postcard features the lovely Grade II listed Palace Theatre which opened its doors to the public on Monday 14 December 1908 'With a High Class Vaudeville Company' under the direction of T. M. Sylvester. When other provincial theatres have sadly closed, the Palace has thrived for over 100 years providing high class and varied entertainment to the local community and beyond. The programme shown below was the 'Famous Farcical Comedy' *Our Boys*, which was performed twice nightly from Monday 21 May 1917. Adjacent to the theatre is the building that was to become the Carlton Cinema. Originally called the Super, this was a conversion of a roller-skating rink, and although it did not provide the ideal shape for a cinema auditorium, everything was done to achieve the best possible conditions, including a seating capacity of 1,228. During late 1930, the Super changed its name to the Carlton and, following extensive alterations, it continued playing to audiences until its closure on Saturday 12 July 1980, after a final film performance of *Zombies: Dawn of the Dead*. The Carlton was demolished in 1982 with the site now occupied, in part, by an extension of the Palace Theatre.

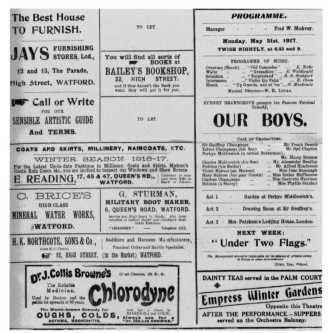

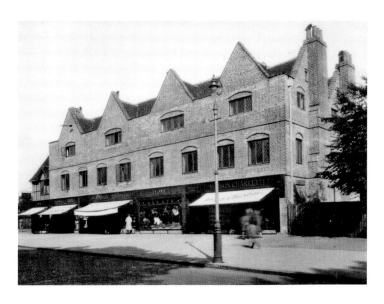

Between what is now Clarendon Road and the Pond were once two large estates, one being the site of Watford House, the home of the County Historian Robert Clutterbuck. Clements' Department Store was later built on this site, latterly the premises of the now defunct T. J. Hughes. The other was the Mansion House, built in 1610 as a Dower House by Sir Robert Carey, the 1st Earl of Monmouth. In 1771, the accommodation was divided into two, the south part being called The Platts and the north called Monmouth House. On Tuesday 3 July 1906 the two properties, together with a block of five brick-built cottages and 'Valuable Freehold Building Land', were put up for auction. The extent of the estate can be seen on the plan below from the auctioneer's particulars. Today, this Grade II listed building is occupied by retail outlets and an Italian restaurant, with office accommodation on the upper floors.

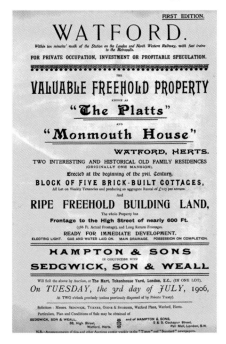

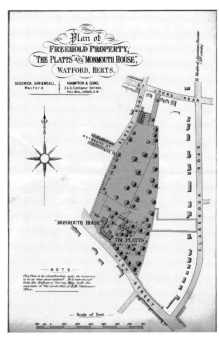

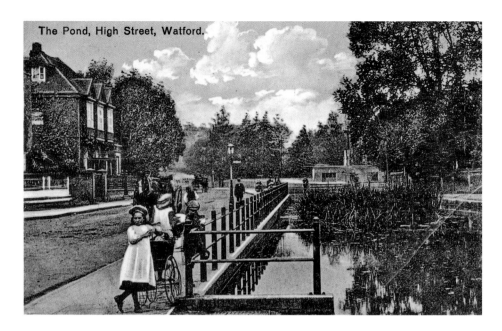

The Pond, High Street, Watford.

Nearly fifty years separates these two lovely images of the Pond situated on The Parade at the northern end of the High Street. During the early 1900s, when the top picture was taken, the Pond was often used for the sailing of toy boats by local youngsters, while many a horse was watered there on a hot summer's day. Also, although the washing of carts was not permitted the practice still continued. By the early 1950s, with railings now in place all round and traffic freely passing up and down the High Street, the days of watering horses was long gone. North of the Pond, the town hall with the roundabout in front can be seen in the middle distance of the 1950s postcard below. Today, with the area now pedestrianised, the Pond is a peaceful oasis where one can while away a few leisurely moments or enjoy a quiet lunchtime snack.

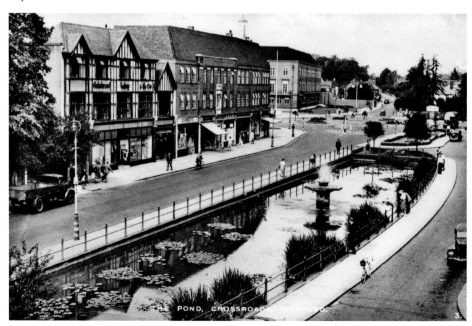

THE POND, CROSSROADS, WATFORD.

This Studio is worth a Visit,

Drawing-room Corner of our Studios.

Because it is by far the most Artistic Studio in this District, and one of the best in the Country. Every Photograph produced is a real work of Art, and satisfactory results are assured to every sitter.

GREGG COUPER & Co.,

The Child and Animal Photographers,

Parade Studios, WATFORD.

KODAK STORES for the Amateur Photographer.

Telephone No. 364.

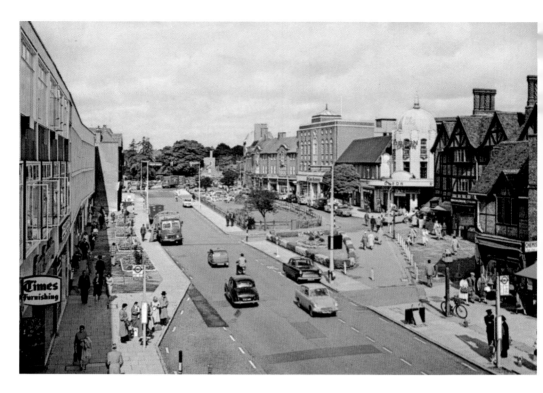

Two nostalgic views of the High Street and the Pond taken in the 1960s. With no restrictions on traffic, this part of the town was still a busy and popular place in which to shop.

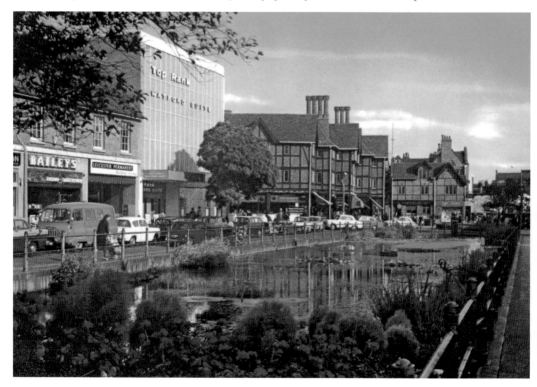

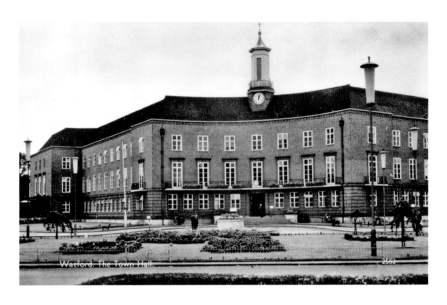

Constructed on the site of The Elms, an eighteenth-century mansion at the north end of the town, at a cost of £186,000, the splendid new Watford town hall was designed by Charles Cowles-Voysey. It was officially opened at 2.15 p.m. on Friday 5 January 1940 by the Countess of Clarendon, who had graciously undertaken to perform the ceremony as Lord Clarendon was unfortunately unable to attend due to indisposition. Bouquets were presented to the Countess and the Mayoress of Watford, Mrs E. R. Andrews by Miss S. Rigby Taylor. Prior to 1940, local government had been carried out at Upton House in the High Street but this accommodation was soon to prove inadequate and larger premises were sought in keeping with the needs of a rapidly growing town. The foundation stone of the new building had been laid by the then mayor, Councillor T. Rigby Taylor on 18 May 1938. (Order of Proceedings courtesy of Dorothy Thornhill MBE, Elected Mayor of Watford.)

BOROUGH OF WATFORD

Official Opening of the

NEW TOWN HALL

BY

THE RT. HON.

THE EARL OF CLARENDON

K.G., G.C.M.G., G.C.V.O.

CHARTER MAYOR OF WATFORD

ACCOMPANIED BY

THE COUNTESS OF CLARENDON

• • •

FRIDAY 5th JANUARY, 1940

• • •

ORDER OF PROCEEDINGS

Order of Proceedings

The guests to be seated in the Hall by 2 p.m.

THE WATFORD SILVER PRIZE BAND WILL PLAY SELECTIONS OF MUSIC

At 2.15 p.m.

HIS WORSHIP

THE MAYOR AND THE MAYORESS OF WATFORD

WILL PROCEED TO THE PLATFORM ACCOMPANIED BY

THE RT. HON. THE EARL OF CLARENDON, K.G., G.C.M.G., G.C.V.O.,

AND

THE COUNTESS OF CLARENDON

THE NATIONAL ANTHEM

Bouquets will be presented to the Countess and to the Mayoress by
MISS SHIELA RIGBY TAYLOR

His Worship the Mayor will invite
THE RT. HON. THE EARL OF CLARENDON
TO DECLARE THE TOWN HALL OPEN

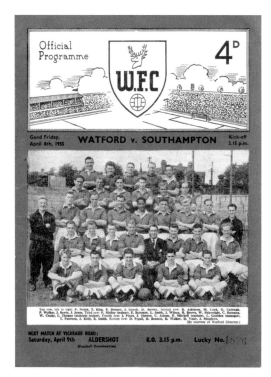

With an attendance of 13,473 at Vicarage Road and the kick-off scheduled for 3.15 p.m. on Good Friday 8 April 1955 Watford was playing at home against Southampton. The final score was 2–1 to Watford. The scorers were Jimmy Bowie and Johnny Meadows who scored a penalty, bringing the home team into the lead, no doubt a brilliant result for the many Watford fans gathered. (Programme courtesy of Watford Football Club.)

WELL SAVED